By Steamer to the Essex Coast

BY STEAMER TO THE ESSEX COAST

ANDREW GLADWELL

AMBERLEY

First published 2012

Amberley Publishing
The Hill, Stroud
Gloucestershire, GL5 4EP

www.amberley-books.com

British Library Cataloguing in Publication Data.
A catalogue record for this book is available from the British Library.

ISBN 978 1 4456 0376 6

Typeset in 10pt on 12pt Sabon.
Typesetting and Origination by Amberley Publishing.
Printed in the UK.

Contents

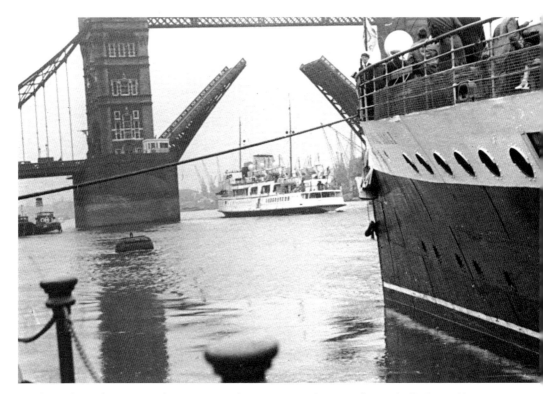

Londoners have always enjoyed a cruise on a pleasure steamer from London to the lively seaside resorts of Southend and Clacton. After disembarking, they were able to sample the delights of these traditional seaside resorts.

Acknowledgements

This book has been written to evoke the heritage and atmosphere of the famous and well-loved pleasure steamers that plied their trade to the equally well-loved seaside resorts of Essex from London and North Kent. This book intends to give a flavour of the famous Eagle Steamers and to show what made their pleasure steamers so special for generations of daytrippers. It's also a gentle look at what passengers found and enjoyed at fun-filled places such as Southend and Clacton. It's a celebration of the piers, resorts and pleasure steamers of the Essex coast. In compiling this book, I have been grateful for the help and co-operation of several individuals. In particular, I would like to thank John Richardson, Roy Asher, James Colville and John Crawford.

Websites

For further information on the heritage of paddle and pleasure steamers:
www.heritagesteamers.co.uk

For details of cruises by the pleasure steamers *Balmoral* and *Waverley*:
www.waverleyexcursions.co.uk

For details of cruises by the paddle steamer *Kingswear Castle*:
www.kingswearcastle.co.uk

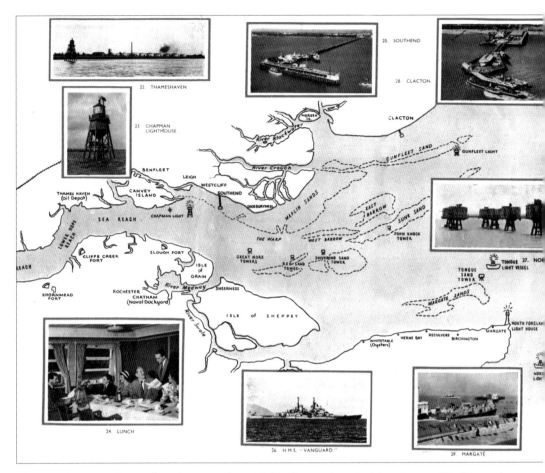

The coastal resorts of Essex have been popular with Londoners since the Victorian era. The best and most popular way of getting to the seaside was by one of the famous Eagle Steamers.

Introduction

The simple pleasure of taking a pleasure steamer trip to the lively seaside resorts of Essex has been a popular day out since Victorian times. Paddle steamer services commenced in the 1820s. At the time, the seaside resorts were very small and nothing at all like the vast, boisterous resorts that emerged in the latter years of the Victorian age. These were the days when steam transport was in its infancy and for the first time people were able to travel easily and quickly to the coast. Early paddle steamers were very small and lacked facilities. Similarly, piers were usually wooden, small and very basic. By the mid to late Victorian era, the design of paddle steamers had evolved to a point where they wouldn't change for many years. Piers had also developed, becoming longer to cater for the larger steamers that were needed for the ever-increasing number of people that wanted a day at Southend or Clacton from London. Piers also become more elaborate, with wonderful pavilions and theatres upon their decks. The marriage of paddle steamer, pier and seaside amusements was at its height. It provided the perfect antidote for those wanting to escape from the hard life of England's capital city.

A day at the coast by paddle steamer was very special for passengers. Paddle steamers gave them a high level of comfort and amenities in the many furnished and well-equipped saloons on board. Here they could enjoy a relaxing trip watching the scenery of the Thames passing by. Others preferred to spend most of the trip from London to Southend in the bar or enjoying the rowdy behaviour of fellow passengers who, like them, were escaping everyday life for just a day or two a year. Paddle steamers also allowed passengers of different classes to travel together. Classes were of course segregated, but décor and space aboard the steamer gave everybody the chance to enjoy a trouble-free trip to the seaside. This, for most, was the most anticipated day of the year.

At the heart of most seaside resorts is a pier. Southend is unique in that its pier is the longest in the world. Many, though, forget that the reason for a pier being a particular length was for it to take large paddle steamers at all states of the tide. In many respects, the town grew up around the pier. The growth of the town reflected the ease by which passengers from London were able to reach it. Southend was

ideally placed to capture the massive trade from London. Seaside towns also developed around the shore-end of the pier. Steamer passengers usually moved very little from the pier when they got off of their ship. In Southend, popular attractions such as the Kursaal and Peter Pan's Playground grew up close to the pier. Likewise, at Clacton the pier, with its massive open-air pool and Blue Lagoon Ballroom, provided all that the tripper required for a day at the seaside. Both Southend and Clacton piers became highly developed, with a vast array of rides, sun lounges, theatres, amusements, restaurants and cafes. These facilities were placed to entice passengers to spend their money on their way to or from the steamer. In the case of Southend, with annual visitor figures running into millions, it was a very lucrative business.

The 1920s and 1930s saw the heyday of Southend Pier. It soon became apparent that significantly larger berthing facilities were needed at the pier head. The Prince George extension was officially opened on 8 July 1929 by HRH Prince George of Kent. This new section of the pier was 326 feet long and cost £58,000. The splendid new facilities enabled a greater number of steamers to visit. Landing platforms at various heights were provided to ensure quick transfer of passengers. With single steamers capable of carrying up to 2,000 passengers, the pier head could become very busy indeed. The 1930s saw a great explosion in the popularity of pleasure steamers. Sleek new motor ships entered Thames service and one of the most famous of them all, *Royal Daffodil*, entered service in 1939.

After peace in 1945, the war-ravaged fleet was replenished. The entry into service of the two new motor ships showed great confidence. After the war, services initially flourished but within a decade they were contracting. Southend and Clacton, like the pleasure steamers that once served them, would never see the good old days return again. By 1950, *Golden Eagle* was laid up and the *Royal Eagle* soon followed. The decline during the following decade was swift and inevitable.

The end came for the General Steam Navigation Company just before Christmas 1966. The three motor ships were to be withdrawn and the *Royal Daffodil* was the first to go. *Queen of the Channel* and *Royal Sovereign* were sold for further service elsewhere. They had quite successful new careers and lasted for quite a while after the *Royal Daffodil. Queen of the Channel* was finally scrapped in 1984 and the *Royal Sovereign* went in 2007.

The decades that followed saw the piers of the Essex coast significantly deteriorate. The arrival of *Waverley* and *Balmoral* on the Thames saw this trend reverse. Their visits from the late 1970s onwards brought the tradition of a pleasure steamer cruise to a whole new generation of passengers. Tragedy has continued to hit Southend Pier. The second most dramatic fire hit the pier at Southend on 7 June 1995 when the shore-end bowling alley was destroyed. A decade later, on 9 October 2005, a large fire destroyed the buildings at the location of the 1899 pier head. As a result of this, the pier train station was destroyed. The cost of this fire was estimated to be around £10 million.

Luckily, the great tradition continues. A pleasure steamer cruise to the Essex coastal resorts is pure nostalgia. For most Londoners, the tradition of going to the seaside was always by pleasure steamer. These steamers, with their happy names, colourful liveries and luxurious interiors, became a memorable annual tradition.

Steamers such as the *Royal Daffodil*, *Royal Sovereign*, *Queen of the Channel* and *Royal Eagle* became part of everyday life. For many, there was simply no other way to visit the seaside! And when they arrived at Southend or Clacton, the day was a great ritual where people visited their best-loved attraction, sat in their favourite gardens and topped their day off with fish and chips and a Rossi ice cream! They then ran along the pier for the journey home to London. Luckily, people are still able to sample this simple but totally joyous day out aboard the *Waverley* and *Balmoral*. The evocative mix of sea air, polished brass, watching the Thames landmarks pass by, a walk along the pier and fish and chips and ice cream at Southend is still as popular as ever! This great London and River Thames tradition is still alive and thriving!

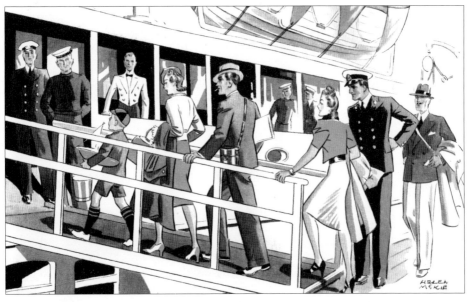

An artist's impression of passengers boarding a steamer, taken from an Eagle & Queen Line illustrated guide dated 1939.

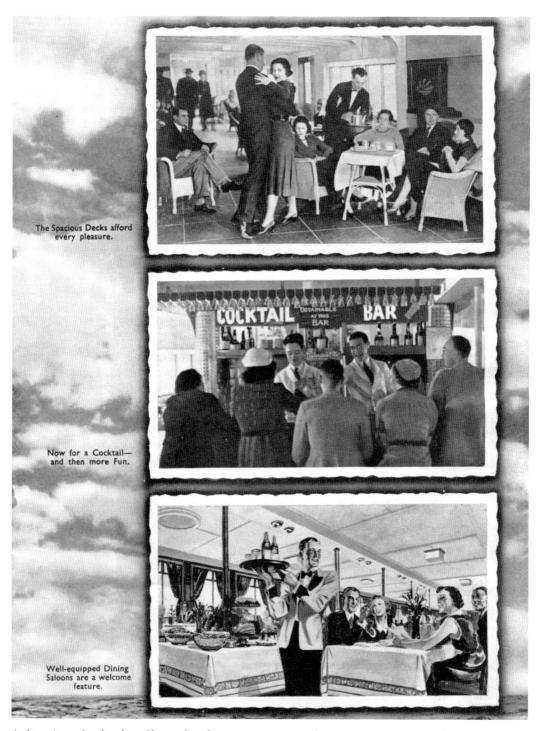

The Spacious Decks afford
every pleasure.

Now for a Cocktail—
and then more Fun.

Well-equipped Dining
Saloons are a welcome
feature.

A day trip to Southend or Clacton by pleasure steamer was always a popular day out for generations of Londoners. These stylish and fast steamers were known as the 'Poor Man's Liners'.

Chapter 1

Departure & Arrival

In the happy and carefree post-war years, one of the most popular family days out was by a pleasure steamer such as the *Royal Daffodil*, *Royal Sovereign* or *Queen of the Channel* to the coastal seaside resorts of Essex.

The 1890s, and later the Edwardian era, witnessed an explosion of pleasure steamer services on the Thames. The earliest Thames paddle steamers were far more basic, with a lack of covered saloons and none of the fine dining saloons that emerged towards the 1880s. This and the image below are from an Eagle Steamer guide. The company was keen to promote its heritage on the River Thames.

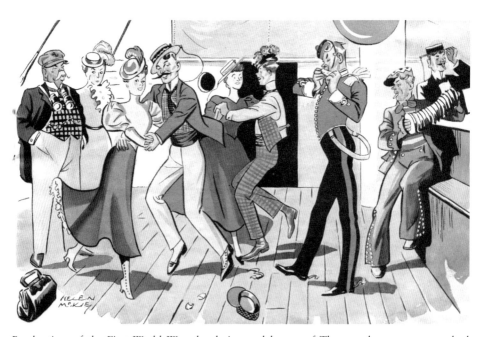

By the time of the First World War, the design and layout of Thames pleasure steamers had evolved. They offered ample and fine covered accommodation linked in with plenty of open deck space to enjoy during good weather. Londoners always enjoyed their day on the steamers and dancing and drinking became popular things to do as the scenery glided past.

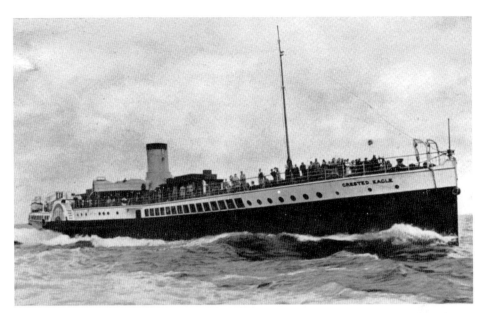

The seaside resorts of Essex have been the beloved seaside home for generations of Londoners since the arrival of the paddle steamer in Victorian times. Pleasure steamers provided the nicest way to visit the seaside, with their fine dining saloons, bars, shops, fresh air and deckchairs. All of these atmospheric delights provided the perfect appetiser for the Londoner who wanted a fun and enjoyable day at the coast. One of the finest paddle steamers to grace the Thames was the *Crested Eagle* of 1925.

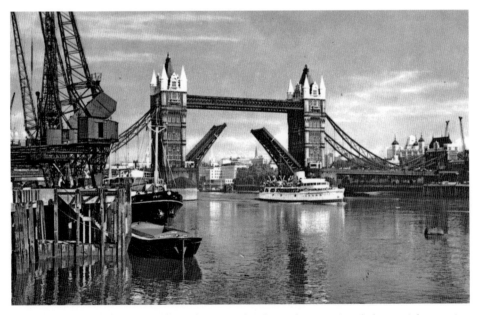

Passengers aboard pleasure steamers from London have always enjoyed the special attraction of Tower Bridge at the start and end of the day. For many Londoners, a day cruise to the Essex seaside resorts was a rare and special event. Money was saved up all year for the treat.

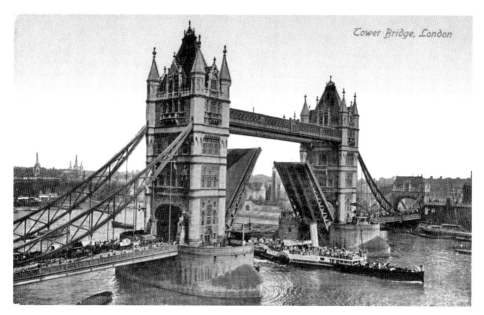

Tower Bridge opened in 1894. Most postcards of it show the bascules open and a paddle steamer passing underneath. The majority of these date from the Edwardian era. The Belle Steamers seem to be the most popular subject. The bridge took 8 years to build and 432 men worked on its construction.

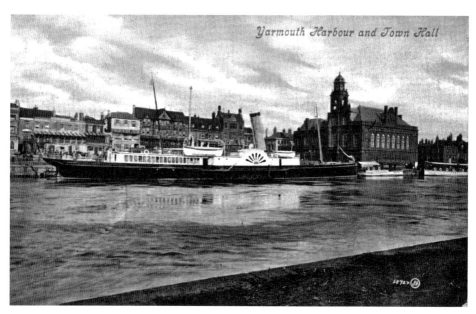

Yarmouth Harbour and Town Hall

Oriole at Great Yarmouth. The Norfolk resort provided the northernmost calling point for Thames paddle steamers. Its considerable distance from London meant that it was never a day trip from the capital. In more recent years, *Balmoral* and *Waverley* have used Great Yarmouth on cruises to London. The cruises to London, with Tower Bridge opening, continue to be very popular.

SAILINGS COMMENCE SATURDAY, 17TH MAY, 1902

NEW PALACE STEAMERS, Ltd.

DAILY SEA TRIPS

FROM TILBURY BY

'ROYAL SOVEREIGN'

DAILY (FRIDAYS EXCEPTED) TO

MARGATE & RAMSGATE

AND BACK,

Leaves Tilbury 11.25; Tender leaves Town Pier 11.14. Leaves Ramsgate 3.15, Margate 4 p.m.

'KOH·I·NOOR'

TO

SOUTHEND & MARGATE

And back on 17th, 18th & 19th May, and Regular Sailings on and after Friday, 4th July.

Leaves Tilbury 10.50; Tender leaves Town Pier 10.30. Leaves Margate at 3.15 p.m.

'LA MARGUERITE'

On and after Tuesday, 1st July, to SOUTHEND, MARGATE, BOULOGNE, CALAIS and OSTEND, allowing about 2½ hours at Boulogne and 2 hours on shore at Ostend.

	2nd SALOON.	1st SALOON.
FARES: To SOUTHEND and Back	2s. 0d.	2s. 6d.
Margate "	4s. 0d.	5s. 0d.
Ramsgate "	4s. 6d.	5s. 6d.

Including Ferry from Gravesend.

Children under 12 Years of Age, Half-price. Refreshments at Popular Prices.

Specially Reduced Fares for Parties of Twelve and over if previously arranged at Agents' or Company's Offices.

and further information, apply to T. E. BARLOW, Director and Manager, 50, King William Street, LONDON, E.C.; T. HUTCHINS, 14, King Street.

A. JARVIS, Local Agent,

18, Bernard Street, 33, East Street, Gravesend, Town Pier and Tilbury.

Printed at "Keble's Gazette" Office, Margate.

Poster advertising sailings by the New Palace Steamers on board the *Royal Sovereign* and the *Koh-i-Noor* in 1902. Cruises were offered from Tilbury and Gravesend's Town Pier to Southend, Margate and Ramsgate.

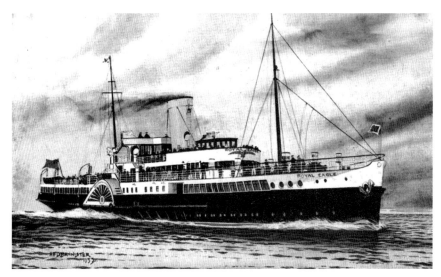

Royal Eagle was launched by Lady Ritchie, whose husband was the Chairman of the Port of London Authority. In a break with tradition, the steamer was launched with a bottle of whisky. *Royal Eagle* was a great favourite for many Londoners. Eagle Steamers became the main operator on the Thames for well over a century and developed high-class steamers famed for their facilities and style. Dining was always an important part of a cruise by Eagle Steamer. Bars were also very popular with Londoners and the consumption of vast amounts of alcohol was often as important as the cruise itself. For those that wanted a more genteel cruise to the coast, there were large and luxurious sun lounges where the prime activity was relaxing to music and watching the scenery of the River Thames pass by.

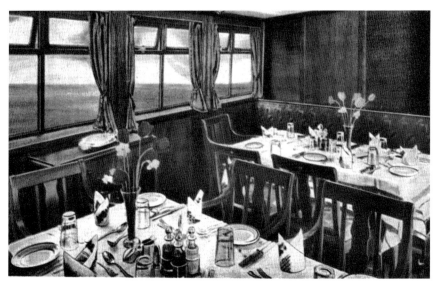

One of the private dining rooms aboard the *Royal Eagle* during the mid-1930s. Passengers could enjoy fine food such as lobster and steak in saloons with crested silver and china. Private party bookings were also encouraged and rooms such as the one shown offered private facilities where groups could enjoy privacy during the cruise.

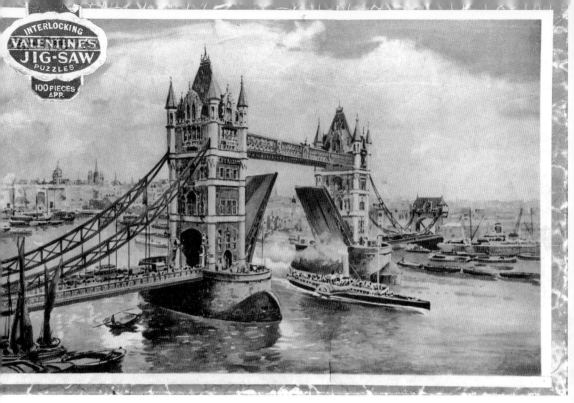

Jigsaws were a popular souvenir of a day at the Essex seaside by pleasure steamer. Tower Bridge, with its bascules opening for a pleasure steamer to pass under, was a natural subject for a jigsaw. Many featured one of the Belle Steamers. Later ones show one of the three famous Thames motor ships.

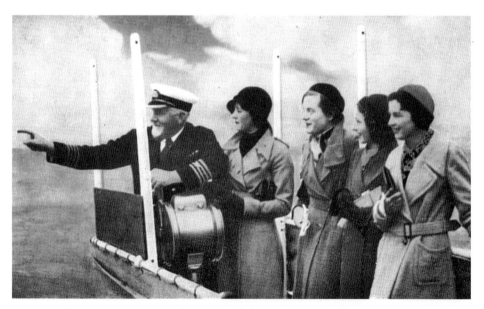

Captain William Branthwaite on the bridge of the *Royal Eagle*. Bill Branthwaite became the master of the *Royal Eagle* when she was delivered from the Merseyside yard of Cammell Laird. He was well known for his happy and friendly personality.

THE THAMES –
– AND ALL THAT

1824–1935

By the mid-1930s, the General Steam Navigation Company was keen to show that it had a fine fleet built on a great tradition of pleasure steamer operation on the Thames. This passenger guide from 1935 shows the more basic facilities of paddle steamers in Victorian times, when ladies showed no ankles!

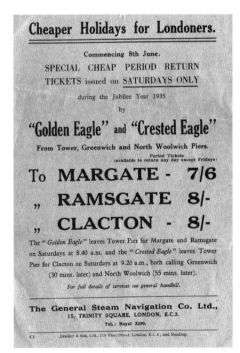

A handbill advertising cruises by the well-known *Golden Eagle* and *Crested Eagle* during the Silver Jubilee year of 1935. *Golden Eagle* entered Thames service in 1909 and was perhaps the finest looking paddle steamer to have graced the Thames. *Crested Eagle* was one of the most distinctive due to her funnel. After departing from London, Greenwich was often the next calling point (30 minutes) and then North Woolwich (55 minutes).

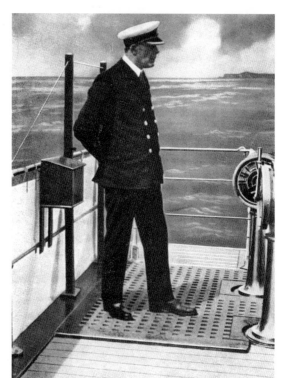

A regular visitor to Southend Pier was Captain Cole of the *Crested Eagle*. He became master in 1925, when the steamer entered service. Captains often became firmly linked with a particular steamer. *Crested Eagle* had an open bridge. This was situated behind the funnel. This and her deck houses were built low so that she could easily negotiate London Bridge.

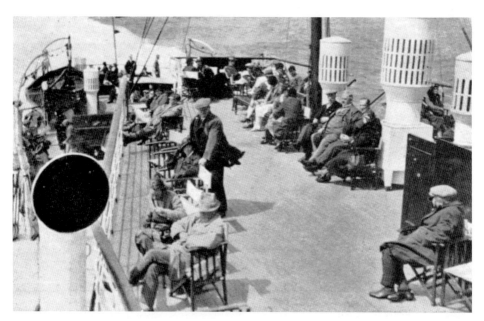

Passengers enjoying a bit of peace and quiet and admiring the view around the mid-1930s. Fresh air and sun were one of the great attractions of a trip to the seaside by an Eagle Steamer as trains could never create that atmosphere. The stern of the promenade deck was also attractive as the sound of the wake from the paddle wheels was very calming.

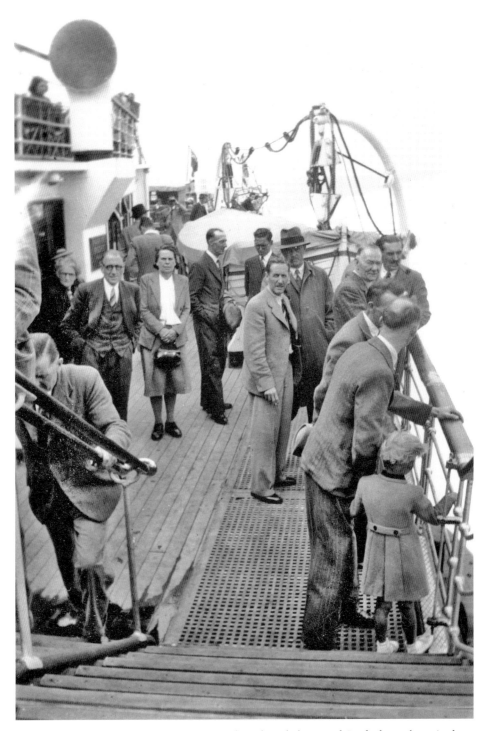

We're off to the sea! Passengers in 1935 gather aboard the *Royal Eagle* for a day trip from London to Southend. Everybody seems to be wearing their 'Sunday best' and the massive, wide decks of the *Royal Eagle* can be appreciated. At the time, a staggering half a million passengers were carried on the River Thames each summer season.

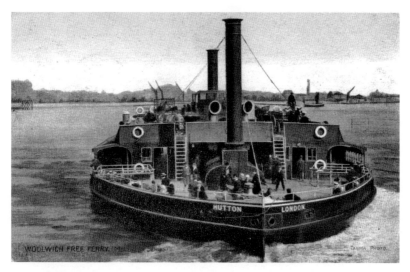

Passengers from London to the Essex coast have always seen the well-known ferries that cross the River Thames at Woolwich. For many years, these ferries were paddle steamers. The *Hutton* was one of these and dated from 1889. For people with little money, a trip across the river was a real treat and it was free. Many others travelled from the south bank to get access to North Woolwich Pier, where the General Steam Navigation steamers often called.

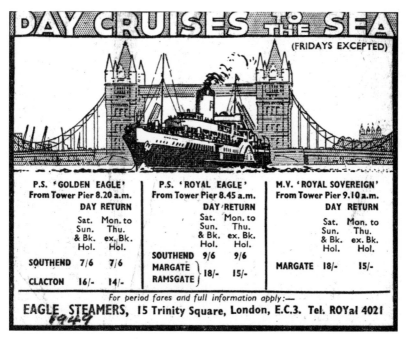

DAY CRUISES TO THE SEA

(FRIDAYS EXCEPTED)

P.S. 'GOLDEN EAGLE' From Tower Pier 8.20 a.m. DAY RETURN		P.S. 'ROYAL EAGLE' From Tower Pier 8.45 a.m. DAY RETURN		M.V. 'ROYAL SOVEREIGN' From Tower Pier 9.10 a.m. DAY RETURN	
Sat. Sun. & Bk. Hol.	Mon. to Thu. ex. Bk. Hol.	Sat. Sun. & Bk. Hol.	Mon. to Thu. ex. Bk. Hol.	Sat. Sun. & Bk. Hol.	Mon. to Thu. ex. Bk. Hol.
		SOUTHEND 9/6	9/6		
SOUTHEND 7/6	7/6	MARGATE } 18/-	15/-	MARGATE 18/-	15/-
CLACTON 16/-	14/-	RAMSGATE }			

For period fares and full information apply:—

EAGLE STEAMERS, 15 Trinity Square, London, E.C.3. Tel. ROYal 4021

Tower Bridge was a wonderful marketing aid for pleasure steamers! *Royal Eagle* looks majestic here in front of the famous London landmark. During the 1930s and 1940s, passengers enjoyed the traditional paddle steamer delights of the *Golden Eagle* and *Royal Eagle*. By the early 1950s, both had gone.

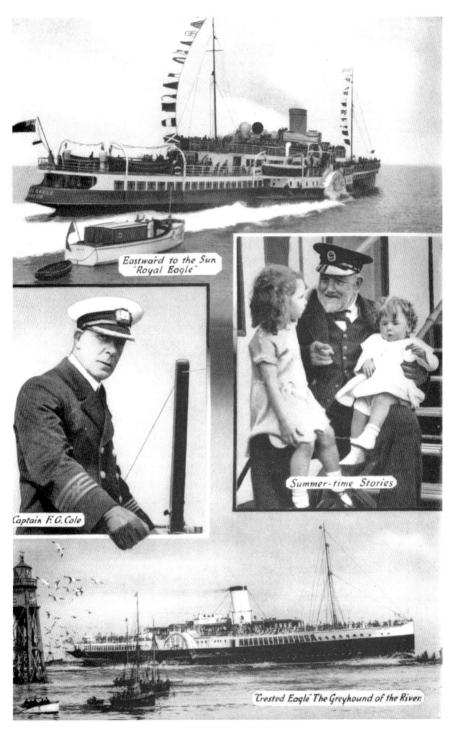

Eastward to the Sun
"Royal Eagle"

Captain F. G. Cole

Summer-time Stories

"Crested Eagle" The Greyhound of the River.

Two famous paddle steamers and their masters: Captain Bill Branthwaite was the well-loved master of the *Royal Eagle* and Captain Cole was the master of the *Crested Eagle*. Many Londoners had a favourite steamer and the jovial, friendly and imposing figure of the captain helped to make their day complete.

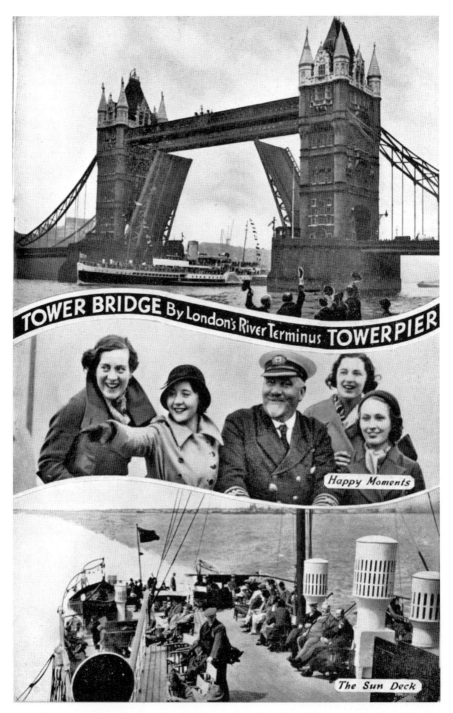

Page from a 1930s guide showing the atmosphere of a River Thames cruise from London to the Essex coast. Londoners were always lucky in that the riverside landscape had a huge number of historic sights, waterside wharves and shipping to interest the passenger. GSN were, though, keen to extract money from their passengers and guides such as these were sold for a few pennies to increase profits. The guides provided a nice souvenir of the day at sea.

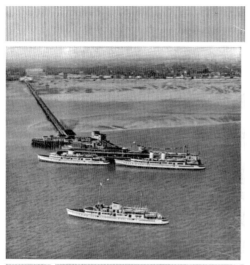

'What's What in Shipping' guide, published around 1955. These guides were sold around the decks for two shillings. They included a huge amount of nautical information. This was used by passengers during the cruise. The Thames at the time was a hive of shipping activity. Passengers were never bored. The image on the left shows the three post-war pleasure steamers of the GSN fleet at Southend Pier. They were the *Royal Daffodil*, *Royal Sovereign* and *Queen of the Channel*.

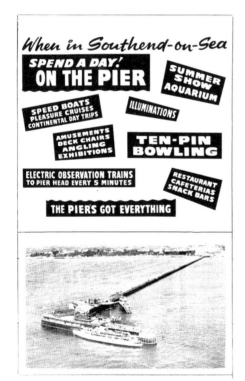

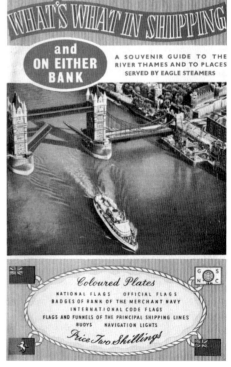

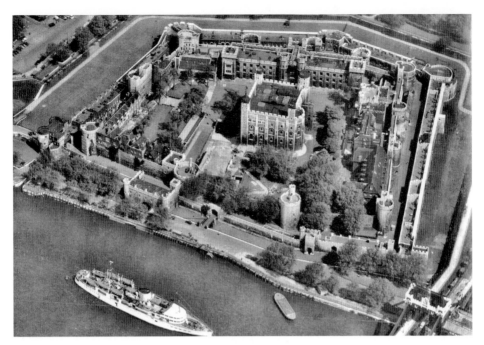

Royal Sovereign, moored close to the Tower of London. The fortress is one of the UK's most popular tourist attractions. Two of its last prisoners were the East End gangsters Ronnie and Reggie Kray. They were locked in cells after absconding during their National Service.

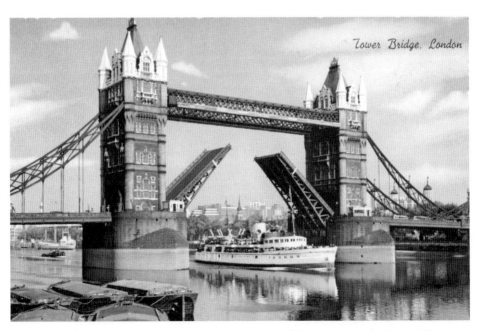

Royal Sovereign departing on a cruise from London. *Royal Sovereign* had the longest life of any of the well-loved Thames motor ships. After withdrawal from Thames service she saw further service in Italy but was barely recognisable from her River Thames heyday.

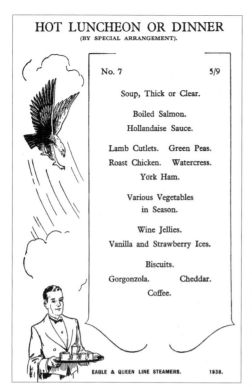

HOT LUNCHEON OR DINNER
(BY SPECIAL ARRANGEMENT).

No. 7 5/9

Soup, Thick or Clear.

Boiled Salmon.
Hollandaise Sauce.

Lamb Cutlets. Green Peas.
Roast Chicken. Watercress.
York Ham.

Various Vegetables
in Season.

Wine Jellies.
Vanilla and Strawberry Ices.

Biscuits.
Gorgonzola. Cheddar.
Coffee.

EAGLE & QUEEN LINE STEAMERS. 1938.

The pleasure steamers to and from Essex always provided high quality catering. During the 1930s you were able to sample vast menus. This one from 1938 is for a hot luncheon or dinner. Dining was conducted in a military fashion and diners only had a set time to consume their meal before the next party were ushered in.

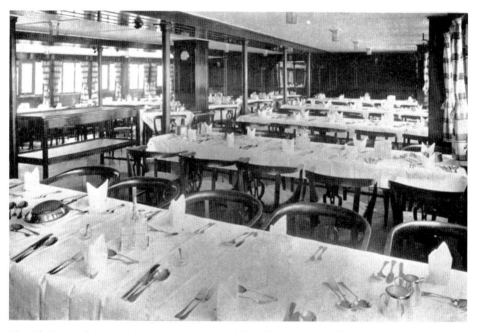

The Aft Dining Saloon of the pre-war *Queen of the Channel*. It was described as being 'palatial' and was huge when compared to facilities on earlier steamers. This pleasure steamer was lost only a few years later at Dunkirk.

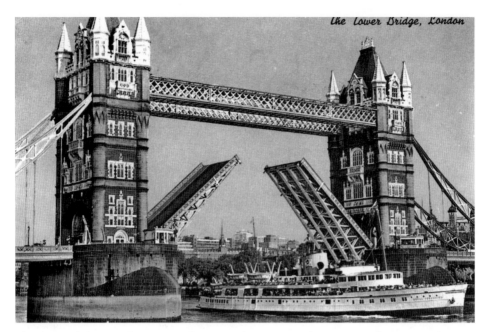

This view of the *Royal Sovereign* shows just how spectacular Tower Bridge was at the start and end of the cruise from London. There wasn't any finer sight to see at the start and end of a day than the most famous bridge in the world opening. The bridge is built on two massive piers sunk into the river bed. Over 11,000 tons of steel provided the framework for the towers and walkways. The framework was clad in Cornish granite and Portland stone to protect the steelwork and to give the bridge a more pleasing appearance.

Queen of the Channel moored in front of the Tower of London around the late 1950s. Some Londoners at this time were unable to afford to travel to Southend or Clacton. Instead, many people had to make do with sunbathing, making sandcastles and paddling on the man-made sandy beach shown here in front of the fortress.

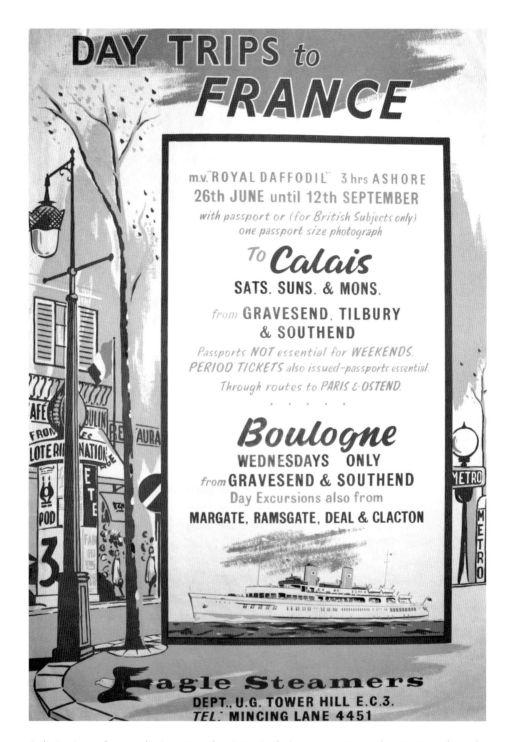

A distinctive and atmospheric poster advertising Eagle Steamer cruises to the Continent from the early 1960s. This poster was produced for the company to promote their Continental services from places such as Southend. At the time, cruises to Boulogne and Calais from Southend were hugely popular.

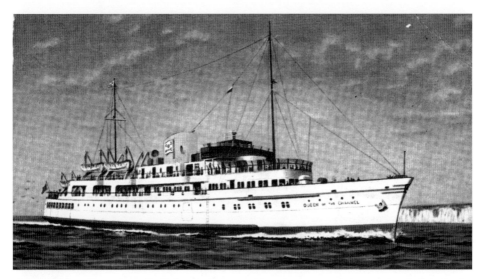

Queen of the Channel was built by the Denny of Dumbarton yard. At 272 feet in length, she could carry 1,363 passengers at a speed of around 18.5 knots. *Queen of the Channel* became the last of the famous and revolutionary motor ships built for Thames service. She was built as a replacement for her namesake, lost at Dunkirk. She looked similar to her sister but could be identified by not having an upper observation lounge forward of the bridge. She entered Thames service on 25 May 1949.

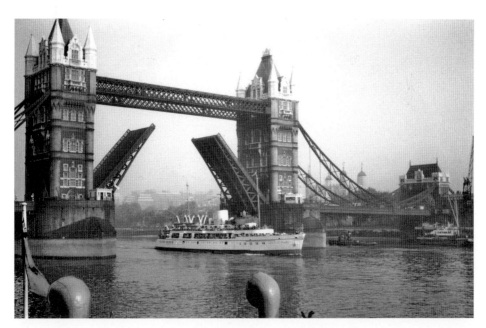

Queen of the Channel departing on a cruise around 1963. On a typical cruise to Southend, most passengers would have a meal or drink and would enjoy a great view of the ever-changing scenery. They might also visit the souvenir shop. During the 1960s, the three large steamers were facing problems. Gimmicks such as bingo and the introduction of penny machines as well as 'Rock & Roll' cruises were all attempts to halt the sad decline.

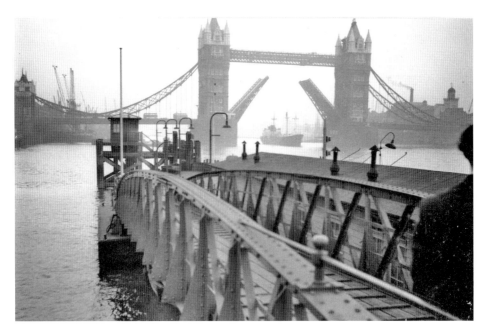

Generations of Londoners joined pleasure steamers for their day at the coast from Tower Pier in London. The pier was opened in 1929 and was well situated, close to railway, bus and Underground links. This view was taken around 1948. The pier was later renewed in time for the Millennium.

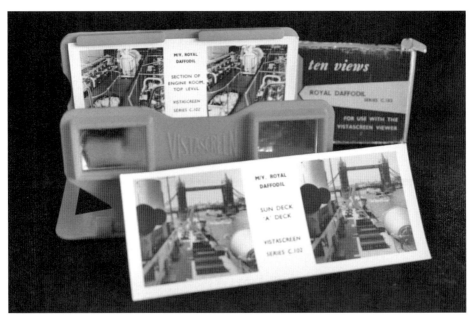

A popular souvenir during the 1960s was a 3D viewer. Vistascreen produced an inexpensive plastic viewer that accepted a set of stereo slides. Some of these views showed areas not normally recorded by passengers, such as the engine room. The popularity of 3D viewers went back to Victorian times. Slides from the time showed paddle steamers and Essex seaside resorts.

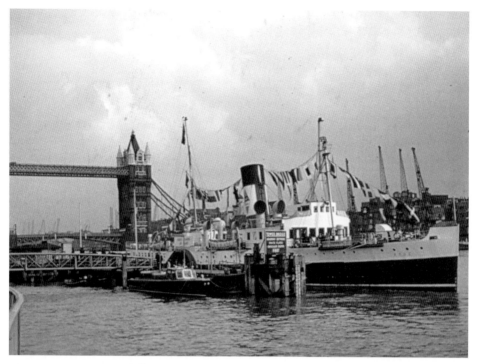

The Portsmouth to Ryde paddle steamer ferry *Ryde* paid a unique visit to the Thames in September 1968. Under charter to Gilbey's Gin, she undertook cruises from London.

Pages from a souvenir fold-out guide to the River Thames from Tower Pier to the sea, issued in around 1963.

The first programme of cruises by Eagle Steamers during 1959. The company relied on the tradition of taking a cruise by pleasure steamer to the coast. Initially, after soldiers had been demobbed at the end of the war, this tradition flourished as men felt nostalgic about going to the seaside by the *Royal Daffodil* again. This position changed very quickly during the 1950s.

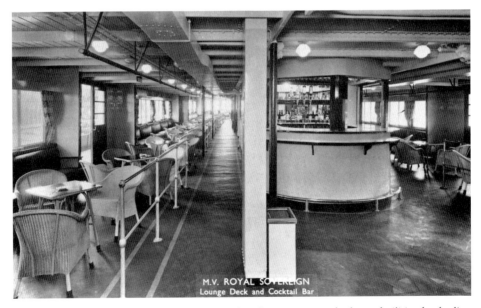

M.V. ROYAL SOVEREIGN
Lounge Deck and Cocktail Bar

A view of the interior of the *Royal Sovereign*. This pleasure steamer had vast facilities for feeding and looking after its passengers as they travelled from London to the coast. You can appreciate the sheer size of the vessel from this photograph.

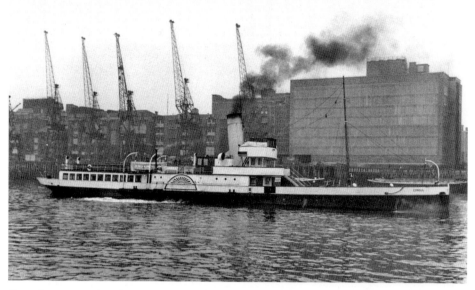

Consul's time on the Thames was very short but she made a welcome addition to the Thames pleasure steamer scene at a time when all fleets were contracting. Londoners were able to sample several historic pleasure steamers in the 1960s. Eventually, all services would cease. The traditional seaside trip would then be by car or train.

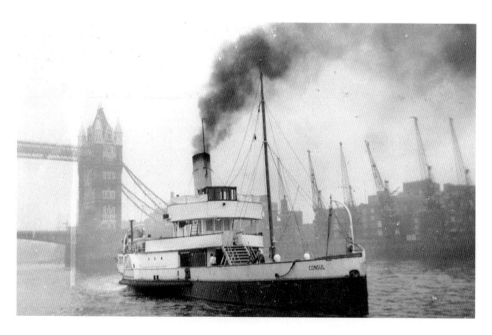

Consul arriving at Tower Pier in September 1963. After a series of trials, tribulations, breakdowns and other difficulties on the Thames, Captain Defrates thought that *Consul* couldn't be steamed back to Weymouth and suggested that a tug be hired to tow her back. This was refused and Captain Defrates then left the *Consul*.

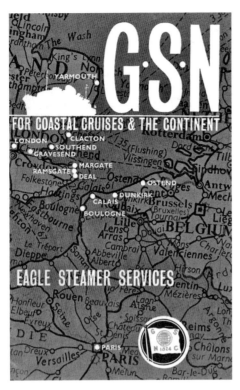

By the mid-1960s, the writing was on the wall for the Eagle Steamers. By this time, pleasure steamers were trying several new services to try and keep going. This included offering services from Great Yarmouth to France as well as from Southend to Paris by steamer and coach. It took ten and a half hours to reach Paris from Southend.

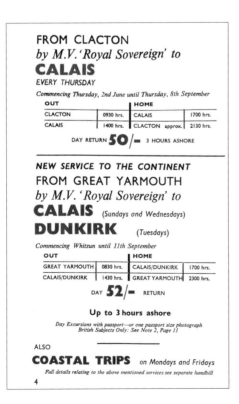

FROM CLACTON
by M.V. 'Royal Sovereign' to
CALAIS
EVERY THURSDAY

Commencing Thursday, 2nd June until Thursday, 8th September

OUT		HOME	
CLACTON	0930 hrs.	CALAIS	1700 hrs.
CALAIS	1400 hrs.	CLACTON approx.	2130 hrs.

DAY RETURN **50/-** 3 HOURS ASHORE

NEW SERVICE TO THE CONTINENT
FROM GREAT YARMOUTH
by M.V. 'Royal Sovereign' to
CALAIS (Sundays and Wednesdays)
DUNKIRK (Tuesdays)

Commencing Whitsun until 11th September

OUT		HOME	
GREAT YARMOUTH	0830 hrs.	CALAIS/DUNKIRK	1700 hrs.
CALAIS/DUNKIRK	1430 hrs.	GREAT YARMOUTH	2300 hrs.

DAY **52/-** RETURN

Up to 3 hours ashore

Day Excursions with passport—or one passport size photograph
British Subjects Only: See Note 2, Page 11

ALSO

COASTAL TRIPS on Mondays and Fridays
Full details relating to the above mentioned services see separate handbill

4

The already established continental pleasure steamer trade was extended in the 1960s to try and halt the decline in passenger numbers. This usually involved long combined steamer and coach journeys. Later on, services as far away as Barcelona were offered.

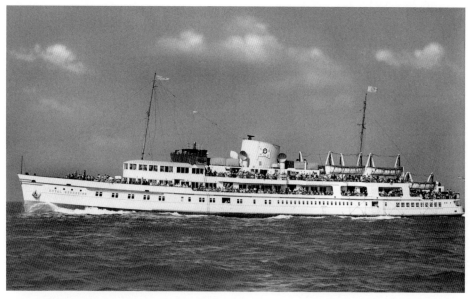

Royal Sovereign during the mid-1960s. From the late 1950s until around 1963, the pattern of cruises changed very little on the Thames. Services to France were popular and around 78,000 people a year travelled to Boulogne and Calais. Services were enhanced by the opening of the new pier at Deal in the late 1950s.

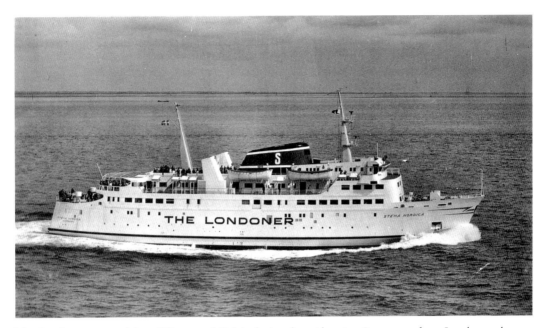

The *Londoner* operated from Tilbury and Calais during the mid-1960s. Passengers from London and Southend were able to join the ship by rail or car. The ship could also offer the then-novel chance to take your car aboard. Up to 126 cars and 1,000 passengers could be carried.

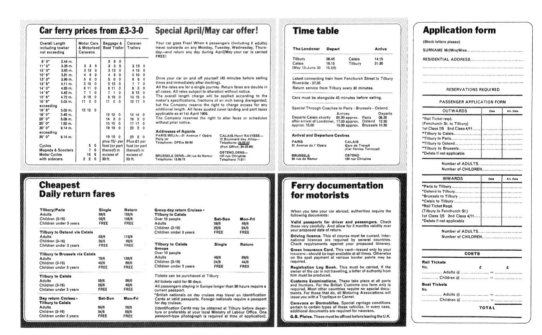

The 1960s were a time of change and new ventures on the Thames. The *Londoner* lacked the looks of the three fine motor ships. It did, though, offer radical new facilities. These included a casino, Swedish smorgasbord restaurant, duty free shop and car parking at Tilbury. Despite these attractions, the venture quickly failed.

Tickets issued by the General Steam Navigation Company around the early 1960s. The company produced a vast array of multi-coloured card tickets. Each of these offered a different type of cruise or meal. Tickets had to be obtained for the deckchair enclosure or for a timed sitting of a meal.

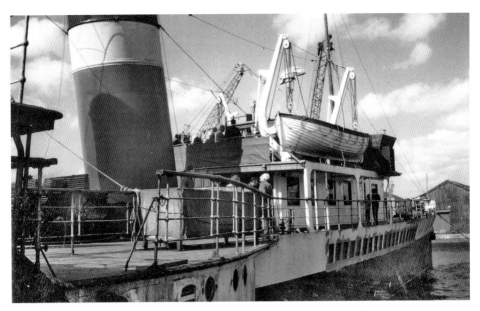

Queen of the South during her refit at Tilbury to prepare her for River Thames service in 1966. Paddle steamers deteriorate rapidly and need a great deal of work to be done to make them fit for service. The transformation of *Jeanie Deans* to *Queen of the South* required a major refit, as can be seen here.

welcome aboard!

new service from the Tower of London and Greenwich to Southend, Herne Bay etc.

PADDLE STEAMER
QUEEN OF THE SOUTH

CRUISE AWAY FOR THE DAY!

This magnificent pleasure ship offers a full season of regular daily sailings (except Fridays) to Greenwich and Southend (for Westcliff, Thorpe Bay and Leigh) with extended cruises on certain days round the coast to Herne Bay, etc.

The 'Queen of the South' has a colourful history — during the Second World War (as HMS 'Jeanie Deans') she led the 11th Minesweeping Flotilla guarding the approaches to the Thames Estuary.

Now, completely reconditioned throughout, and fitted with most modern equipment such as Decca Radar 303, she still retains an atmosphere of leisurely luxury and charm reminiscent of traditional 'riverboat' cruising. Earlier this year she was fitted with a bow rudder as a further refinement, as well as specially designed paddle-guards.

Here indeed is a steamer of character and distinction; speedy and modern, yet with lines which delight the eye—a vessel acclaimed by connoisseurs and public alike.

There is so much to do on board—stroll at will around the vast expanse of deck, visit the Souvenir Shop, enjoy a quiet drink, have a meal at the 'Captain's Table'—dance to the exciting Mellotrone. Games and competitions are arranged for the children, and young and old can engage in the traditional pastime of going down to see the engines'. (The stirring sight of gleaming cranks, whirling and plunging majestically as they drive the giant paddle wheels, is something that only a ship of this type can offer).

The 'Midshipman's Bar' on the Promenade Deck enables passengers to quench their thirst and still view the passing scene as the vessel proceeds smoothly down river to Southend, or out into the open sea to Herne Bay. In the 'Admiral's Bar' on the Lower Deck an exciting variety of wines and spirits are available.

Excellent hot and cold meals at reasonable prices are served in the 'Captain's Table' Restaurant. For light snacks, the 'Bosun's Room' on the Main Deck is the answer, and in the Soda Fountain, soft drinks, ice-cream and confectionery of every description are available.

Fresh and succulent Leigh cockles, Margate shrimps and Whitstable whelks will be on sale at the Sea Food Bar, whilst the Mellotrone gives passengers the chance to dance in a genuine 'Showboat' atmosphere.

On 'Queen of the South' we have tried to think of everything for your comfort and pleasure, even if you ask no more than a quiet hour's rest on the Sun Deck, lying in a reserved chair with nothing to disturb you but the gentle rhythm of the paddles.

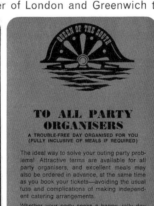

TO ALL PARTY ORGANISERS

A TROUBLE-FREE DAY ORGANISED FOR YOU (FULLY INCLUSIVE OF MEALS IF REQUIRED)

The ideal way to solve your outing party problems! Attractive terms are available for all party organisers, and excellent meals may also be ordered in advance, at the same time as you book your tickets—avoiding the usual fuss and complications of making independent catering arrangements.

Whether your party seeks a happy, jolly day out, or just simple relaxation from every-day cares, they are sure to appreciate the journey, the day's enjoyment and individual freedom to pass the time on board in any way they please.

If YOUR party would like to enjoy a wonderful day out, write NOW for further details of special party rates, to:—

A. E. MARTIN & CO. LTD. Managers for
COASTAL STEAM PACKET CO. LTD.

52-53 Crutched Friars, City of London, E.C.3.
Tel: ROYAL 0281-4 · Telex: 22472

Booking Office — Sailings from SOUTHEND only—
Pier Approach, Tel. SOUTHEND 67505.

FARES
FROM LONDON
(Please state when booking, if boarding at Tower or Greenwich Pier)

TO SOUTHEND

Day Return **Monday to Thursday**	17/6
Day Return **Saturday and Sunday**	19/6
Single Daily except **Friday**	10/-

TO HERNE BAY

Day Return **Monday, Tuesday and** **Wednesday only**	25/-
Single **Monday, Tuesday and** **Wednesday only**	15/-
EVENING CRUISE (From Tower Pier only) 10/-	

★ Children half price
★ Cafeteria Service also available for teas, light meals and snacks
★ Fully licensed bars (open all day) with wide selection of refreshments at popular prices
★ Special fares quoted to organised parties of old-age pensioners and certain charitable organisations, for travel on Mondays, Tuesdays, Wednesdays and Thursdays only during June and September.
★ Evening cruise, special cuisine including wine.

TIME TABLE
Commencing Saturday, June 10th, 1967

Mondays, Tuesdays* & Wednesdays		Thursdays, Saturdays & Sundays	
Dep. Tower Pier 9.45 am		Dep. Tower Pier 9.45 am	
Dep. Greenwich		Dep. Greenwich	
Pier 10.15 am		Pier 10.15 am	
Arr. Southend 1.30 pm		Arr. Southend 1.30 pm	
Dep. Southend 2.00 pm		Dep. Southend 4.30 pm	
Arr. Herne Bay 3.15 pm		Arr. Greenwich	
Dep. Herne Bay 4.30 pm		Pier 7.30 pm	
Arr. Southend 5.45 pm		Arr. Tower Pier 8.00 pm	
Dep. Southend 6.00 pm			
Arr. Greenwich		**Thursdays, Saturdays &**	
Pier 9.00 pm		**Sundays, Evening Cruise**	
Arr. Tower Pier 9.30 pm		from **Tower Pier** commencing Saturday, June 17th. Departs 8.45 pm; returns 11.00 pm	

* On occasional Tuesdays from July onwards, vessel may not sail to Herne Bay, but will instead depart from Southend to an alternative destination. Further details later

Timetable, fares and a general introduction for the *Queen of the South*'s services on the Thames.

AQUARIUS

400 piece
jigsaw puzzle

size 14″x 18″

Jigsaw showing the *Queen of the South* tied up at London. *Queen of the South* is often mistaken for the *Waverley* as they both bore the LNER livery at the start of their main as well as in their later careers.

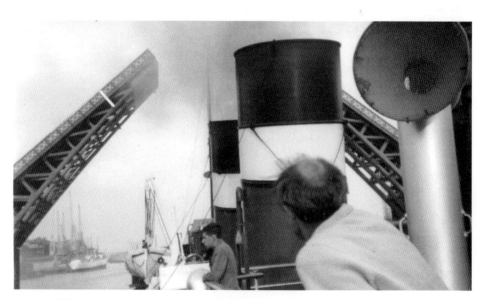

Queen of the South passing under Tower Bridge on 1 July 1967. *Queen of the South* entered Thames service in May 1966 and almost immediately cruises were cancelled or curtailed. The problem mainly lay with mechanical and boiler problems. Bad publicity and ill-feeling gave her a poor reputation.

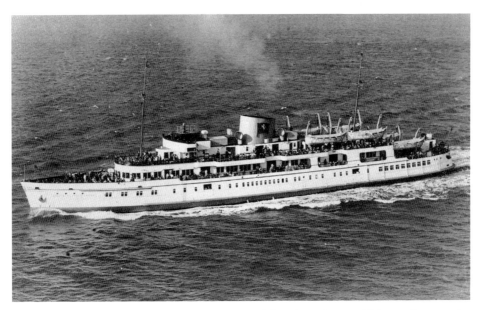

Queen of the Channel during the 1950s. *Queen of the Channel* was withdrawn from service during the mid-1960s and saw further service elsewhere. She was later considered as a fleetmate for the *Waverley* during the 1980s.

Medway Queen alongside Southend Pier, viewed from the *Royal Daffodil* on 14 July 1949. The pier was experiencing its post-war peak at this time.

Newspaper advertisement for *Queen of the South* from Tower Pier in 1966. At this time, the car was taking over from the pleasure steamer as the preferred method of transport for a day at Southend. This steamer did, though, make a fine effort to attract Londoners that were hungry for a bit of nostalgia as well as to attract a new young market with onboard dancing and music.

PADDLE STEAMER
QUEEN OF THE SOUTH

DOWN THE THAMES AND ROUND THE COAST
SHOWBOAT-STYLE!
Music, Dancing – Everything for your enjoyment

Commencing Saturday June 10 – New daily service (except Fridays)
Tower of London and Greenwich Piers to Southend, Herne Bay, etc.

EXCURSIONS!
Day Return Southend 17/6 (Sats & Suns 19/6)
Day Return Herne Bay 25/-.
Half Price for Children.
Departs Tower 9.45 a.m. – Greenwich 10.15 a.m.
Excellent luncheons, high teas, etc.
Reasonable prices.
Fully licensed bars open all day.

WONDERFUL CRUISE FROM ONLY 17/6

Special inclusive rates for parties of pensioners, charitable and other groups.

Details, brochure on request from:
COASTAL STEAM PACKET CO. LTD.
Managers: A. E. MARTIN & CO. LTD.,
Dept. A. 52-53 Crutched Friars, City of London, E.C.3. Tel: Royal 0281

Commencing WHIT-SATURDAY, 28th MAY
Until further notice

DAILY SAILINGS
(Fridays excepted)

Through calm and sheltered waters

direct from

THE HEART OF LONDON (Tower of London Pier)
and
GREENWICH PIER (Next " Cutty Sark ")
to
HISTORIC
GRAVESEND
and

London's Playground
SOUTHEND-ON-SEA for Leigh, Westcliff, and Thorpe Bay
Approximately 5½ hours ashore.

ALSO REGULAR SEA CRUISES TO

Happy Healthy
HERNE BAY and Sunny CLACTON
Up to 3½ hours ashore. Up to 1½ hours ashore.

PLUS

★ Circular Cruises calling at Herne Bay (non-landing), thence to **Southend** with up to 3 hours ashore before return to London.

★ Combined Steamer and Coach Trips
 (a) Through the lovely Essex countryside to picturesque **Maldon** or **Burnham-on-Crouch**.
 (b) Across Kent to medieval **Canterbury**.
 (c) Interesting River and Road Tours via Gravesend, visiting **Maidstone** (for the famous Market), and ancient **Rochester** (for the early Norman Castle and Cathedral).

★ A variety of similar excursions to the Hop Fields and other Kentish beauty spots, (full details to be announced shortly).

Cruises to Southend aboard the *Queen of the South* also linked in with coach trips to nearby picturesque towns such as Maldon and Burnham-on-Crouch.

The
CAPTAIN'S TABLE
Dinner Menu

Paddle Wheel Specials to start your meal

Tomato Soup with Sherry and fresh cream
or
Chilled Melon and Grapefruit Cocktail
or
Prawns - Captain's style

Full Steam Ahead with

Sirloin Steak with chips and peas
or
Golden Fried Scampi
or
"Queen of the South" Cold Meat Platter

Anchors Down with

Sailors Cassata
or
Fresh Pineapple and cream
(*when available*)
or
Fruit from the basket
or
Cheese from the tray
(*as an extra course 2/6*)

and to finish your meal

Coffee served black or with fresh cream (1/6 extra)

The
Captain's Table
on board the p.s. "Queen of the South"

Splice the Main Brace

A schooner of Sherry
before your meal 3/6

**WINE AND BEER
SELECTION**

Carafe Wines

Red, White or Rosé

	Bottle	15/-
	½ Bottle	8/-
	By Glass	3/-

Kriter, Champagne type wine

	Bottle	27/6
	¼ Bottle	8/-

Beers

Light Ale	2/-
Brown Ale	2/-
Worthington	2/3
Lager	2/6

A CENTRE RESTAURANT

Head Office: St. James Court
Buckingham Gate, S.W.1
Tel. 01-834 2360

Themed menu and bar list from the *Queen of the South* in 1966. Its 'Captain's Table' menu offered patrons a typical 1960s bill of fare. Meals were served in the splendid 1930s dining saloon. *Queen of the South* arrived on the Thames after a stormy trip from the Clyde in November 1965. After her lengthy rebuild, it was intended to operate her on every day apart from Friday. Her regular timetable would see her cruise from Tower Pier, London, to Southend, Herne Bay and Clacton. The Clacton cruise was an early casualty of her disastrous Thames career and she ran this less than ten times. She was finally towed away on 27 December 1967 to be broken up at Antwerp.

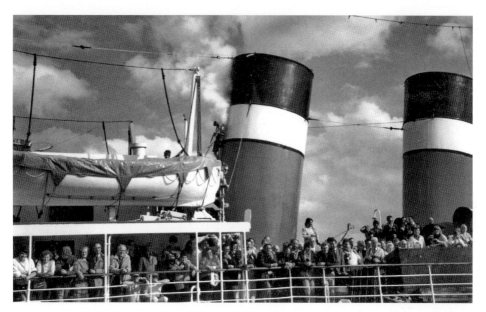

Waverley arriving at Tilbury in 1989. *Waverley* and *Balmoral* undertake many of the well-loved routes of the Eagle Steamers. Southend Pier is important to the schedule due to the attractiveness and nostalgia of the resort for Londoners. Other piers, such as those at Margate, Herne Bay and Deal, are no longer available. New piers have emerged such as Woolwich Pier as well as Gravesend's Town Pier.

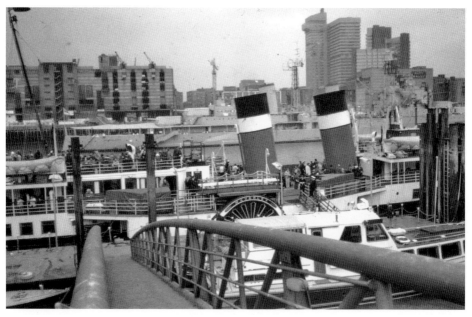

Waverley at London's Tower Pier. It has always been an exciting moment as passengers view the pleasure steamer for the first time. *Waverley* has been an annual visitor to the River Thames and London since the late 1970s. She's now as familiar to Londoners as many of the old pleasure steamers were.

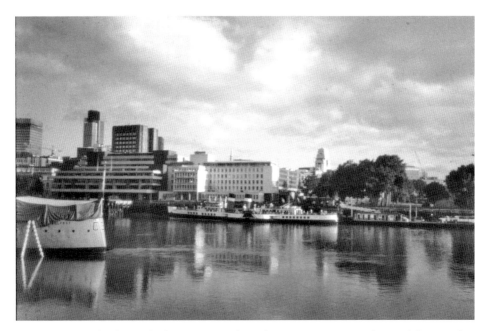

Waverley moored at her embarkation point of London Tower Pier around 1980. This area has changed a great deal since *Waverley* first visited. Hays Galleria has been developed, Tower Pier is new, City Hall and adjoining offices have been built and the City of London skyline has changed dramatically. The latest addition of the 'Shard' gives ship spotters a unique view of *Balmoral* and *Waverley* from a height of around 1,017 feet.

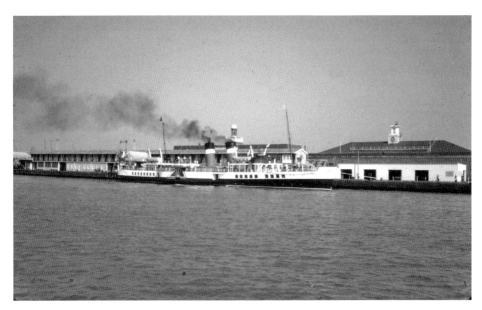

Waverley making one of her early calls at Tilbury in 1980. Tilbury became the mid-way calling point for *Balmoral* and *Waverley* until the re-opening of the Town Pier at Gravesend to pleasure steamer traffic in 2012. Hundreds of thousands of passengers have boarded the steamer at Tilbury for the one-and-a-half-hour cruise to Southend.

Passengers crowding the decks of *Waverley* on the River Thames in 1989 as she passes some of the new riverside developments. *Waverley* has witnessed great changes in the riverside landscape since her arrival on the Thames. The closure of the London docks and their redevelopment has given her passengers a perfect platform to view the changing landscape.

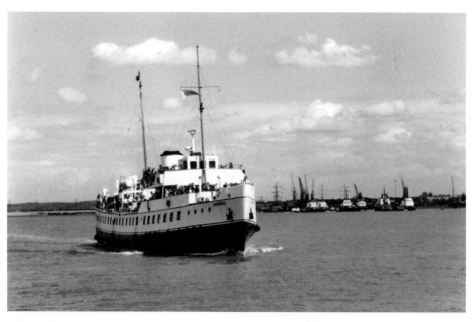

Balmoral is passing Gravesend on her way to London. Gravesend was a popular calling point for paddle steamers in the early Victorian era as Londoners visited the beautiful pleasure gardens at nearby Rosherville. Rosherville had its own pier adjacent to the gardens.

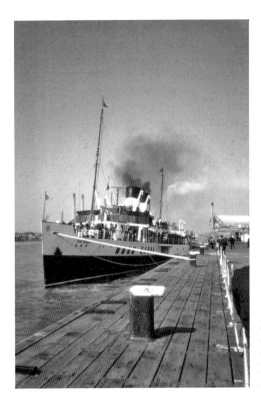

Waverley moored at Tilbury in May 1980. It's now two hours since the steamer departed from London and *Waverley* stops to pick up more passengers. One and a half hours later, *Waverley* arrives at Southend to disembark her hundreds of passengers.

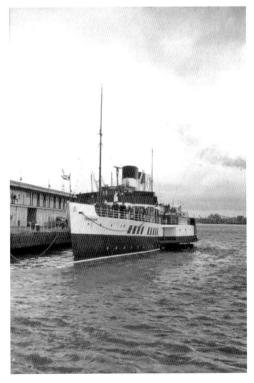

Waverley departing from Tilbury in 1983.

Kingswear Castle has visited the Thames and London since the mid-1980s, when she re-entered service. This 1924-built, coal-fired paddle steamer is shown approaching Greenwich Pier around 1985. This pier is rarely used these days. Attractions such as the Royal Naval College, Greenwich Meridian and *Cutty Sark* provide more than ample sights for passengers on a pleasure steamer.

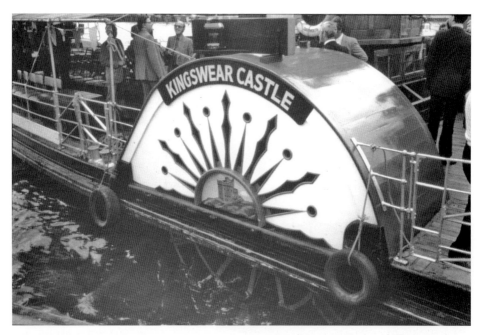

Kingswear Castle's paddle box. Paddle boxes were usually very ornate and decorative affairs and further enhanced the bright and happy atmosphere of a paddle steamer. They would normally have a finely carved centre panel showing a figure or place associated with the name of the steamer. Here you can see the carving of Kingswear Castle in Devon.

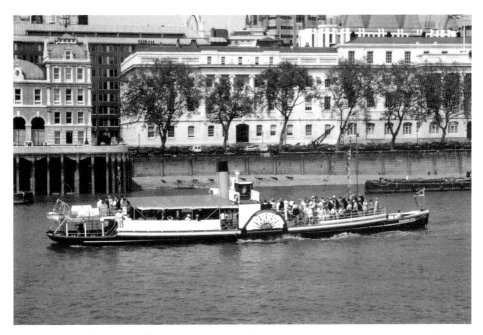

Kingswear Castle on one of her cruises from London around 2000. In her early days at London she used London Tower Pier but on her final visits, she used London Bridge City Pier.

Kingswear Castle for many years offered annual cruises to and from London. She is shown here in June 1987. It was usual for *Kingswear Castle* to cruise to London one day and to then undertake charters before returning to her base at Chatham the following day. *Kingswear Castle* and *Waverley* are in the Core Collection of the National Historic Fleet in the UK.

Balmoral has now spent more years on the Thames than her predecessors such as *Royal Daffodil*, *Royal Sovereign* and *Queen of the Channel*. She was originally built in 1949 for service between Southampton and Cowes. Her 1986 livery was similar to that of the 1950s Eagle Steamers.

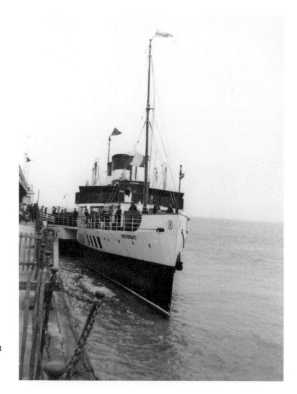

Waverley alongside Southend Pier on one of her early visits to the Essex resort.

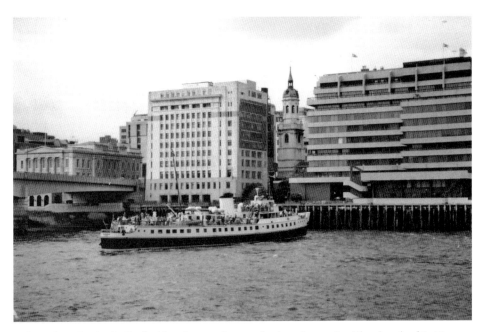

Balmoral turning in the Pool of London, ready to embark on her cruise. The church of St Magnus the Martyr is now dwarfed by modern buildings. Changes continue to take place along the river and the landscape changes at great speed. The building of the 2012 Olympic stadium and park saw further developments take place. This included a one-kilometre-long cableway over the Thames capable of carrying 2,500 people per hour in each direction.

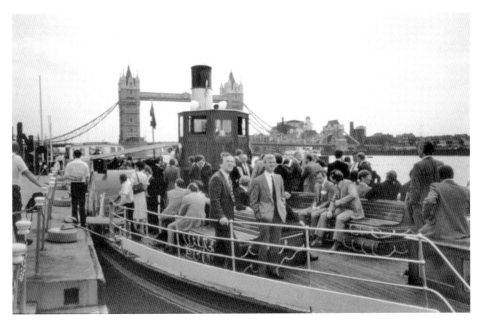

Kingswear Castle alongside London's Tower Pier around 1985. *Balmoral*, *Waverley* and *Kingswear Castle* are now the UK's main providers of classic coastal cruising. Each steamer has been fully restored to reflect its rich heritage.

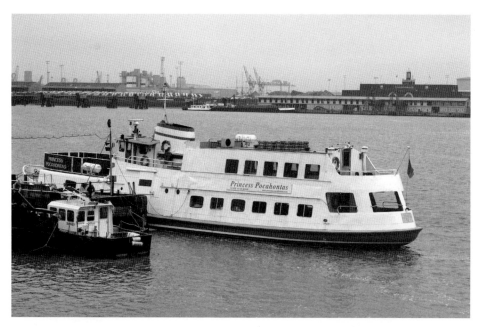

Princess Pocahontas arrived on the River Thames in the late 1980s. Her regular service is from Gravesend and Tilbury to Southend as well as up the Thames to London as far as Chelsea. Her plentiful covered accommodation has made her popular with groups. She was built in 1962 and can carry up to 300 passengers.

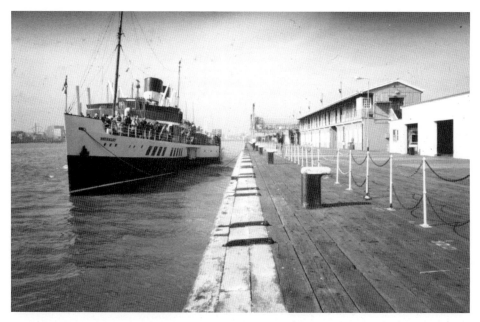

We're nearly there! *Waverley* is seen leaving Tilbury for Southend. At this point, the river opens out and the industry and buildings that occupied the river banks close to London change to low-lying banks. Closer to Southend, Canvey Island is reached and then the interlinking towns of Leigh-on-Sea, Chalkwell, Westcliff and finally Southend.

Brochure advertising cruises by the *Waverley* and *Balmoral* to and from Southend during the 2010 season. By this time, cruises were offered from places as distant as Rye, Great Yarmouth and Southwold, with many return journeys being undertaken by coach.

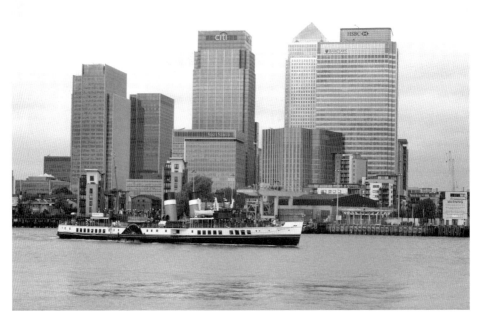

Waverley passing the skyline of Canary Wharf in October 2010.

Chapter 2

Southend & Its Pleasure Steamers

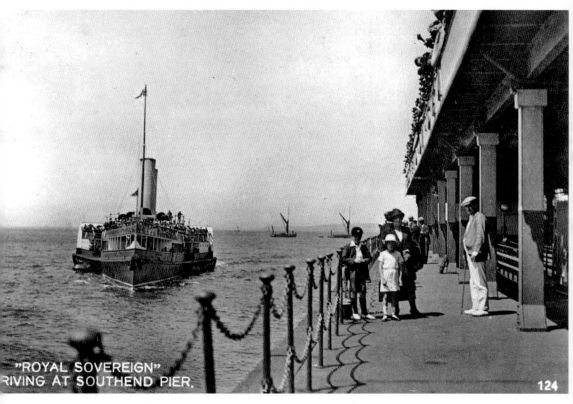

"ROYAL SOVEREIGN" RIVING AT SOUTHEND PIER.

124

Southend has always been the favourite Essex seaside destination for generations of Londoners. The paddle steamer *Royal Sovereign* is shown here arriving at its famous pier in the mid-1920s.

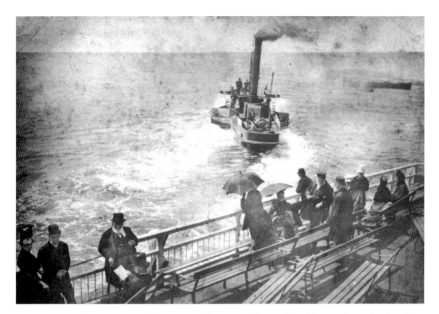

A rare view showing an early steamer departing from the old wooden pier head at Southend. The town welcomed its first pleasure steamer in 1819 but it was to take another decade before the first real pier was built. This original pier was built of oak and was around 600 feet in length, opening in June 1830. As steamer services developed, the pier at Southend was extended. Between 1834 and 1835, it was lengthened and additional platforms were added. Just a decade later the pier was extended again and for the first time it managed to provide decent facilities for visiting steamers. At this time, it was extended to a mile and a quarter.

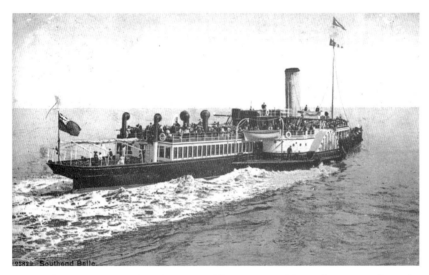

Southend Belle was one of the famous paddle steamers of the Belle Steamer fleet. The Belle Steamers had a virtual monopoly of Thames steamer services towards the end of the nineteenth century with their fine new fleet. They competed with the older GSN steamers. The prominence of the Belle Steamers was short lived in an era of fierce competition.

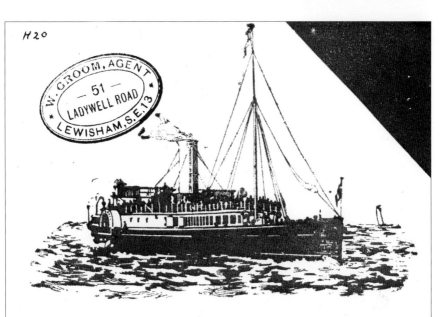

H20

W. GROOM, AGENT
— 51 —
LADYWELL ROAD
LEWISHAM, S.E.13

5 HOURS ASHORE
AT
SOUTHEND

EXCURSION **3/6** RETURN FARE.

SUNDAYS

EXCURSION **4/-** RETURN FARE.

☞ ASK FOR FREE TICKET TO THE KURSAAL WHEN BOOKING

Every Day, except Fridays and Saturdays
(UNTIL FURTHER NOTICE)

FIRST EXCURSION, JUNE 7th, 1927.
BY

YARMOUTH or SOUTHEND BELLE.

Greenwich - 9.15. North Woolwich - 9.40.

BOOK AT 51 LADYWELL ROAD, S.E.13

Head Office: East Anglia Steamship Co., Ltd.,
91/93, Bishopsgate, London, E.C.2.

Hubbard, Loughton

The Belle Steamers were regular callers to the piers at Southend, Clacton and Walton from the 1890s onwards. Their names were also quite unique as each one was each named after a pier used by the company. This handbill advertises day trips to Southend from Greenwich and North Woolwich during 1927.

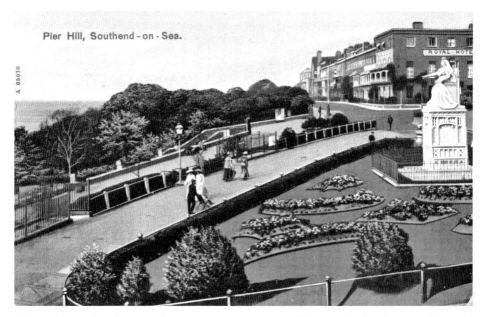

Pier Hill, Southend-on-Sea.

The Royal Hotel and statue of Queen Victoria on Pier Hill at Southend. Adjoining the Royal Hotel is Royal Terrace. This fine parade of houses and hotels was visited by Princess Caroline of Brunswick in 1803. She had been recommended to bathe in the sea at Southend by her practitioner.

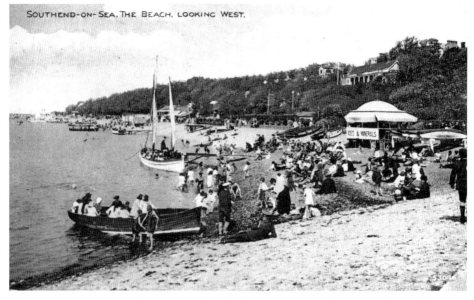

SOUTHEND-ON-SEA. THE BEACH, LOOKING WEST.

Daytrippers to Southend often think of mud when they visit. At low tide, the mud flats are revealed and these reach far out towards the pier head. The present pier was of course built to overcome the limited access provided by the original pier. As steamers grew, so the pier had to grow as well. The original pier dated back to around 1802. This very small affair was used to ferry guests of the Royal Hotel ashore.

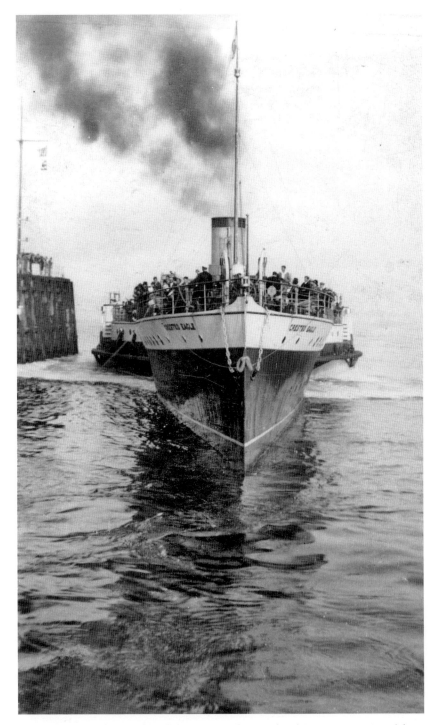

A splendid view of *Crested Eagle* being secured at Southend Pier in 1936, viewed from the *Royal Eagle*. The fine shape of the hull can be appreciated in this view, along with the tremendous width of the *Crested Eagle* across the paddle wheel area. She only managed a couple more seasons at Southend before being lost during the Second World War.

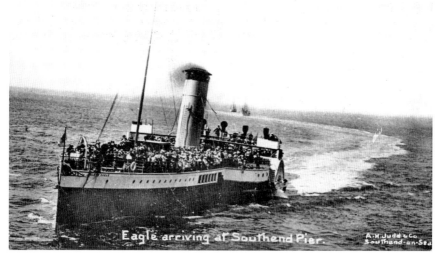

The *Golden Eagle* arriving at Southend Pier around 1910. The Edwardian era saw facilities at the pier head develop. An amazing 6,000 people could be accommodated in the various sun lounges and cafés. Many of these must have admired the pleasure steamers arriving and departing.

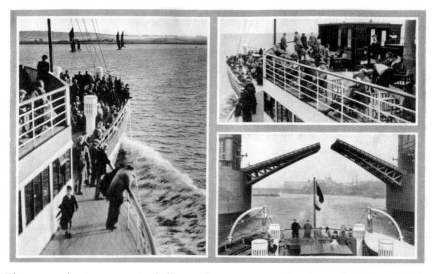

The 1930s, despite economic challenges, became an era of style on the Thames. Eagle & Queen Line introduced the *Royal Eagle* in 1932 and later in the decade confidently introduced several more new pleasure steamers. These reflected the age and looked totally different to what had been seen before. They were capable of carrying huge numbers of passengers quickly and efficiently between London and Southend.

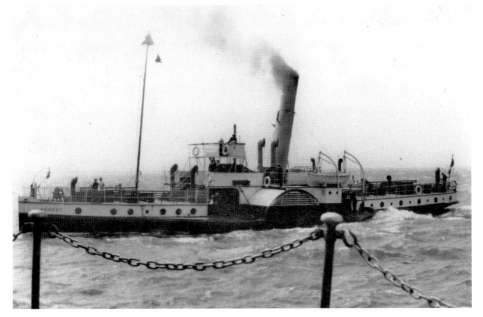

The delightful little *Audrey* arriving at Southend Pier around the mid-1920s. *Audrey* was operated by Captain Shippick of the New Medway Steam Packet Company. The company became very successful during the 1920s and 1930s when it embarked upon an ambitious expansion of the fleet. *Audrey* was scrapped during the late 1920s as the larger steamers were built or acquired.

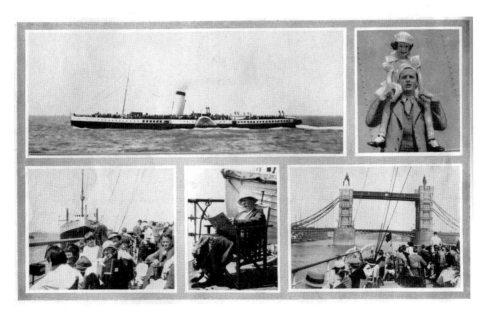

The *Golden Eagle* was built in 1909 and was a great favourite with Southend passengers. Eagle Steamers nicknamed it 'The Happy Ship'. By the 1930s, *Golden Eagle*'s set lunches had been replaced by a buffet in order to cater for the sheer number of passengers on its cruises.

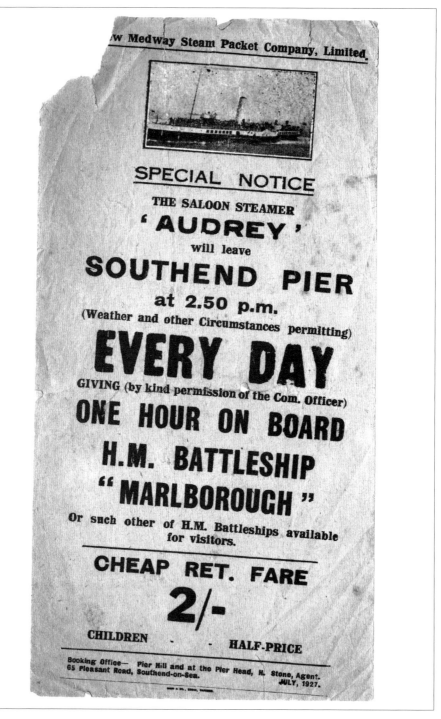

...w Medway Steam Packet Company, Limited.

SPECIAL NOTICE

THE SALOON STEAMER

'AUDREY'

will leave

SOUTHEND PIER

at 2.50 p.m.

(Weather and other Circumstances permitting)

EVERY DAY

GIVING (by kind permission of the Com. Officer)

ONE HOUR ON BOARD
H.M. BATTLESHIP
"MARLBOROUGH"

Or such other of H.M. Battleships available
for visitors.

CHEAP RET. FARE

2/-

CHILDREN - - HALF-PRICE

Booking Office— Pier Hill and at the Pier Head, R. Stone, Agent.
65 Pleasant Road, Southend-on-Sea.
JULY, 1927.

A very early handbill advertising cruises from Southend Pier during the 1927 season by the *Audrey*. Steamers often provided cruises from the pier to visit nearby battleships at anchor. Passengers were offered the novel opportunity to go aboard the battleships as part of the cruise. This visit was to the *Marlborough*.

QUEEN LINE STEAMERS
(NEW MEDWAY STEAM PACKET CO., LTD).

EVERY DAY (FRIDAYS EXCEPTED)

AFTERNOON SEA CRUISE
(Weather and other circumstances permitting).

"FATHER NEPTUNE"
WILL BE ON BOARD TO DISTRIBUTE PRIZES

Come and Join in the Fun!

On the *FAST SALOON STEAMER*

(And/or other Queen Steamer)

Leaving Clacton Pier at 2.30 p.m.
CALLING AT WALTON

And Arriving Back at Clacton about 4.0 p.m.

SEA CRUISE—Return Fare 1/6
(Children Under 14 Years 9d.)

Also "BOAT AND BUS" TICKETS can be obtained to go by Steamer to WALTON and return to CLACTON by any Service Bus

COMBINED RETURN FARE 1/9 Child 11d.

FREE ADMISSION TO PIER WITH STEAMBOAT TICKETS
4 p.m. to SOUTHEND, etc. & LONDON (4/- Single to London)

SPECIAL NOTICE

Book at the Queen Line Office, Pier Entrance

AND MAKE SURE YOU GET "QUEEN" TICKETS

REFRESHMENTS ON BOARD AT POPULAR PRICES.
Sailings and/or Services may be Suspended or Altered Without Notice

Further Particulars from Agent — P. NUNNELEY, THE PIER, CLACTON
(Phone Clacton 94) or Clacton 557.
Head Office, 365/367, High Street Rochester. — Tel. Rochester 2204/2205.
S. J. SHIPPICK, Managing Director.

Clacton News; Printers.

Handbill for afternoon cruises by the *Queen of Southend*. Queen Line steamers utilised novel marketing techniques to attract passengers, as shown on this handbill. They also made use of bus services at this time to offer more cruise options.

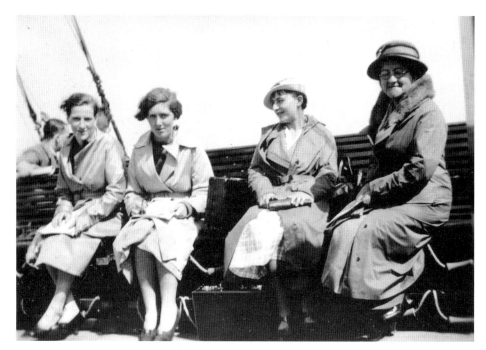

Passengers aboard a paddle steamer on a cruise from Southend to visit a Royal Navy battleship at anchor in June 1935. Each day, pleasure steamers such as the *Royal Daffodil* or *Golden Eagle* required around ten tons of stores such as meat, vegetables, ice cream, beers and wine. This had to be loaded during a very short period between 6.00 a.m. and 8.00 a.m.

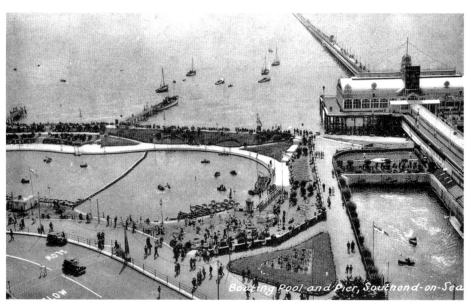

Motor boats were a popular attraction in the early to mid-twentieth century. The pool alongside the pier on the left was later used as the home for the Golden Hinde waxworks. The Spanish Inquisition tableau at the front of the attraction was a popular attraction with children for many years as they watched the torture scene with its gruesome detail.

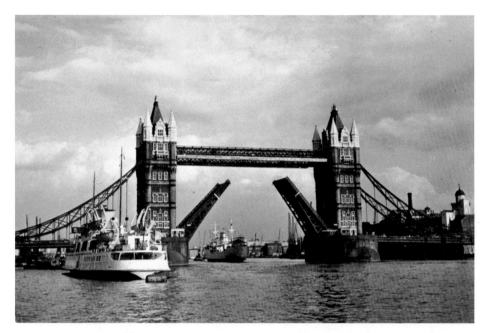

1 An Eagle Steamer is moored opposite the Tower of London around the early 1960s. At the time, Tower Bridge was very busy as dockside wharves in the Upper Pool of London were still working. By the 1970s and 1980s, this had changed and the bridge was opened less often.

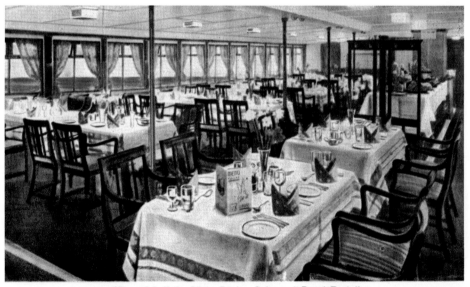

View of half the Main Dining Saloon: "Royal Eagle."

2 Part of the dining saloon of the *Royal Eagle* during the mid-1930s. This saloon could accommodate an astonishing 322 diners at a time. It had large windows for passengers to enjoy the coastline during their meal. This and the fine silver plate, china and furniture clearly show that this room was available for first class passengers.

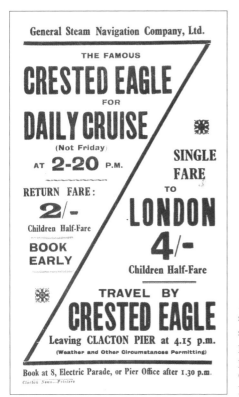

General Steam Navigation Company, Ltd.

THE FAMOUS

CRESTED EAGLE
FOR

DAILY CRUISE
(Not Friday)

AT **2-20** P.M.

SINGLE FARE

RETURN FARE:

2/-

Children Half-Fare

TO

LONDON
4/-

Children Half-Fare

BOOK EARLY

TRAVEL BY

CRESTED EAGLE

Leaving CLACTON PIER at 4.15 p.m.
(Weather and Other Circumstances Permitting)

Book at 8, Electric Parade, or Pier Office after 1.30 p.m.
Clacton News—Printers

3 One of the most distinctive of all Thames paddle steamers was the *Crested Eagle*. This steamer had a short and fat funnel that folded down to allow it to pass under London Bridge. At the time, the steamer provided a regular service to and from London. Clacton passengers were able to book cruises at the Electric Parade or at the pier.

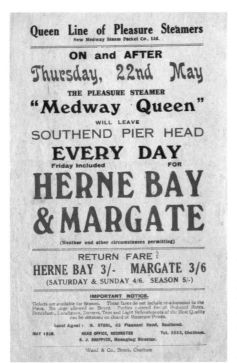

Queen Line of Pleasure Steamers
New Medway Steam Packet Co., Ltd.

ON and AFTER

Thursday, 22nd May

THE PLEASURE STEAMER

"Medway Queen"

WILL LEAVE

SOUTHEND PIER HEAD

EVERY DAY
Friday Included FOR

HERNE BAY
& MARGATE
(Weather and other circumstances permitting)

RETURN FARE :
HERNE BAY 3/- MARGATE 3/6
(SATURDAY & SUNDAY 4/6. SEASON 5/-)

IMPORTANT NOTICE.
Tickets are available for Season. These fares do not include re-admission to the Piers. No dogs allowed on Board. Parties catered for at Reduced Rates. Breakfasts, Luncheons, Dinners, Teas and Light Refreshments of the Best Quality can be obtained on Board at Moderate Prices.

Local Agent : H. STONE, 65 Pleasant Road, Southend.
MAY 1930. HEAD OFFICE, ROCHESTER. Tel. 2055, Chatham.
S. J. SHIPPICK, Managing Director.

Wood & Co., Brook, Chatham

4 One of the best loved paddle steamers that visited Southend Pier was the *Medway Queen*. This early handbill from 1930 announces her cruises from the pier to Herne Bay and Margate. Return fares to Herne Bay were three shillings during the week, with much higher fares at weekends. *Medway Queen* offered similar cruises right up until she was withdrawn from service in September 1963.

5 Guide showing the *Royal Eagle* produced in the mid-1930s. It heavily promotes the *Royal Eagle*, which arrived on the River Thames in 1932. Passengers were often entertained during cruises by special competitions, visits by costumed characters and by singers. Eagle Steamers did all that they could to provide an entertaining trip to the Essex coast.

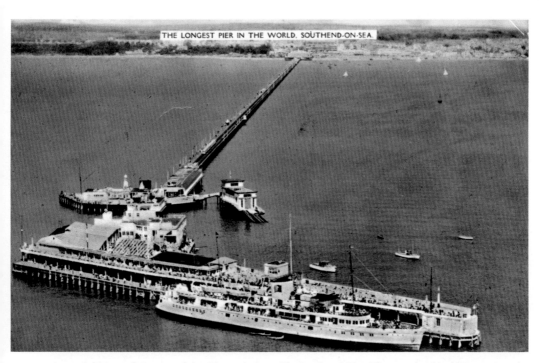

THE LONGEST PIER IN THE WORLD, SOUTHEND-ON-SEA.

6 An aerial view of *Queen of the Channel* alongside Southend Pier. The massive berthing arm can be appreciated in this view. The Prince George Extension, built in the 1920s, provided the finest berthing facilities in the UK. Despite there being fine amusements and entertainments at the end of the pier, the landing of passengers by pleasure steamer was just as important.

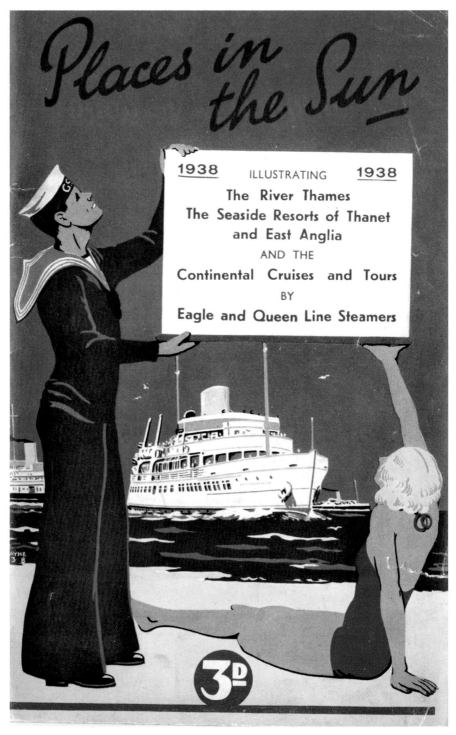

7 'Places in the Sun' guide for the Thames for the 1938 season. The cover shows one of the two new motor ships that had just entered service. *Queen of the Channel* and *Royal Sovereign* were promoted as 'London's Luxury Liners' and feature prominently in this guide.

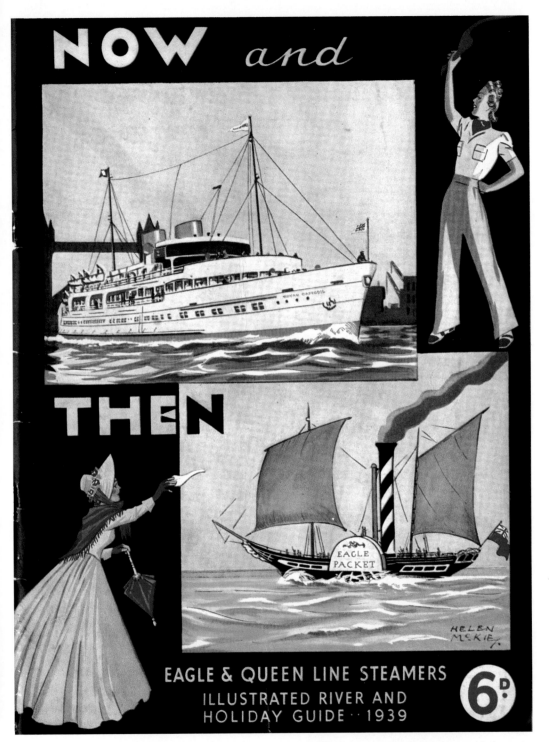

8 Front cover from the Eagle & Queen Line guide for the 1939 season. The guide provided a great advertisement for the company. It showed the wonderful modern pleasure steamers such as the *Royal Daffodil* against the early steamers of the company in the mid-nineteenth century.

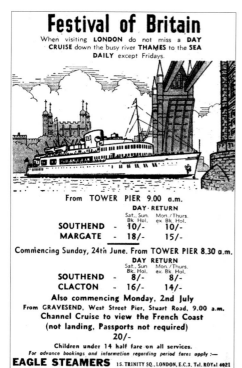

Festival of Britain

When visiting **LONDON** do not miss a **DAY CRUISE** down the busy river **THAMES** to the **SEA**

DAILY except Fridays.

From TOWER PIER 9.00 a.m.

	DAY · RETURN	
	Sat., Sun. Bk. Hol.	Mon./Thurs. ex Bk. Hol.
SOUTHEND -	10/-	10/-
MARGATE -	18/-	15/-

Commencing Sunday, 24th June. From TOWER PIER 8.30 a.m.

	DAY RETURN	
	Sat., Sun. Bk. Hol.	Mon./Thurs. ex Bk. Hol.
SOUTHEND -	8/-	8/-
CLACTON -	16/-	14/-

Also commencing Monday, 2nd July

From GRAVESEND, West Street Pier, Stuart Road, 9.00 a.m.

Channel Cruise to view the French Coast
(not landing, Passports not required)

20/-

Children under 14 half fare on all services.

For advance bookings and information regarding period fares apply :—

EAGLE STEAMERS 15. TRINITY SQ., LONDON, E.C.3. Tel. ROYal 4021

9 It's 1951 and 'Festival of Britain' year. Families visiting the festival on the South Bank were also able to sample a day at the seaside at Southend, Clacton or Margate. The 'Festival of Britain' was hugely popular and attracted some 8.5 million visitors during its five months of opening. The most popular attractions were the 'Skylon' and the 'Dome of Discovery'.

SCENIC VIEW *Cocktail* COASTER

CUT ON DOTTED LINE

- -

10 A novel souvenir of a pleasure steamer! This postcard transforms into a 'scenic view' cocktail coaster with the use of scissors.

11 Eagle Steamers published a series of humorous postcards titled 'Life on the Ocean Wave'. Each postcard showed a comical cartoon based on a nautical term.

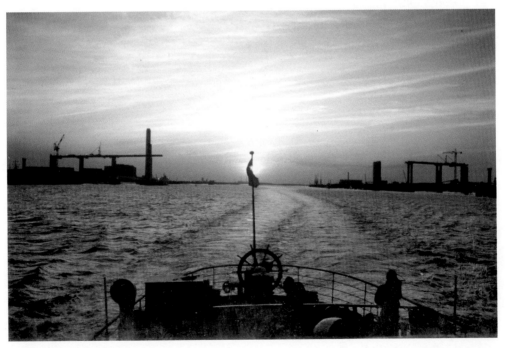

12 Daytrippers from London to the Essex coastal resorts have seen the River Thames change considerably over the years. The Queen Elizabeth II Bridge at Dartford was one of these changes in the late 1980s. This view from 1989 shows the bridge from *Waverley* at sunset just before the two approaches were joined together.

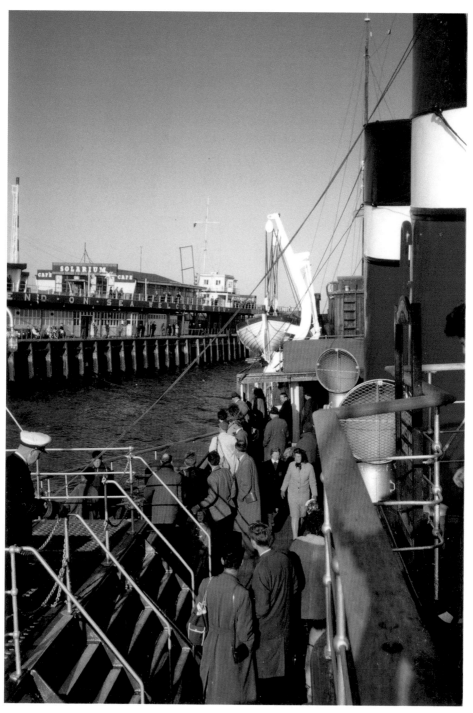

13 'Southend-on-Sea Welcomes You' – this was the greeting that awaited each and every pleasure steamer visitor to the pier during its post-war heyday. If you look on the board at the centre of the pier head buildings, you will see the letters of this slogan attached to the pier. The pleasure steamer shown in the image is the *Queen of the South* during the mid-1960s.

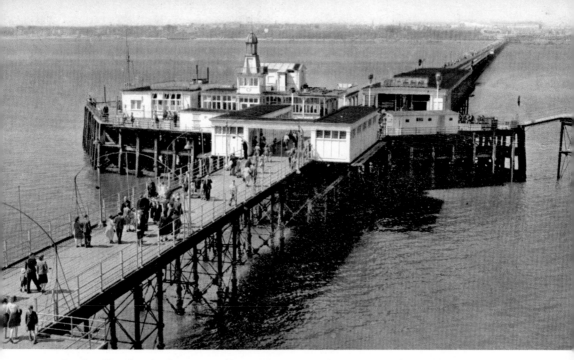

14 Southend Pier has the distinction of being 'The Longest Pleasure Pier in the World' at 1.3 miles. It's also remembered for something else. Sadly, the pier has suffered a number of catastrophic fires that have affected its attractions. These include major fires in 1976, 1995 and 2005.

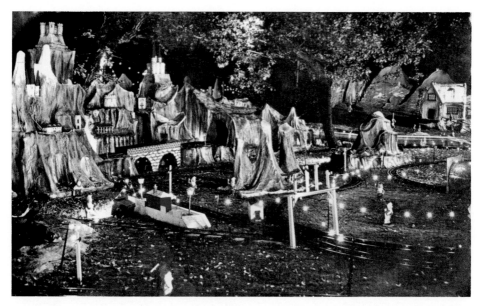

15 Southend had many attractions, including its annual illuminations. The phrase 'By the Dome its Known' became synonymous with the Kursaal and it appeared in many Eagle & Queen Line guides. The Kursaal Ballroom was a local landmark and dancers were entertained by some of the most famous bands in the UK. The Ted Heath Orchestra, Cleo Laine and Vera Lynn all entertained in the Kursaal Ballroom.

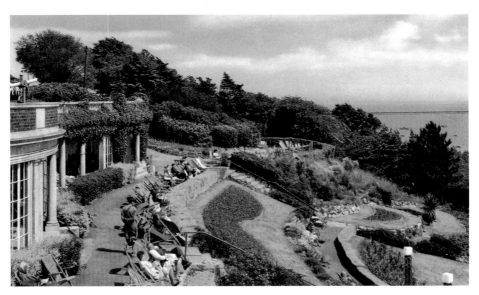

16 Westcliff is situated around a mile west of Southend Pier. The area between the pier and Cliffs Pavilion is occupied by splendid cliff-side gardens with colourful flower beds. Most passengers from pleasure steamers would have flocked to the boisterous delights of the Kursaal and Peter Pan's Playground at Southend. Westcliff tended to attract those wanting a more sedate place to relax. They were also afforded a fine view of pleasure steamers arriving and departing from the pier from the high and relaxing vantage point.

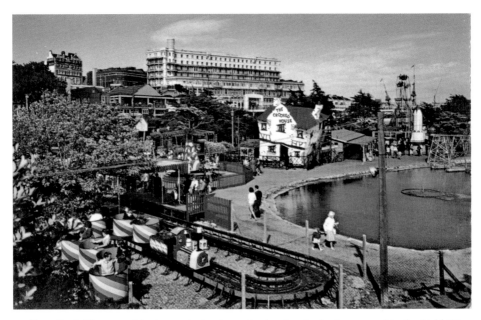

17 Peter Pan's Playground is shown during its 1960s heyday. In the foreground is the Gold Mine ride. The Crooked House is also clearly visible, with the Zoo behind. The attraction is still operating although it has been enlarged and transformed from the view on this 1960s postcard. Twenty-first-century steamer passengers are still able to enjoy the pleasures of this famous amusement park.

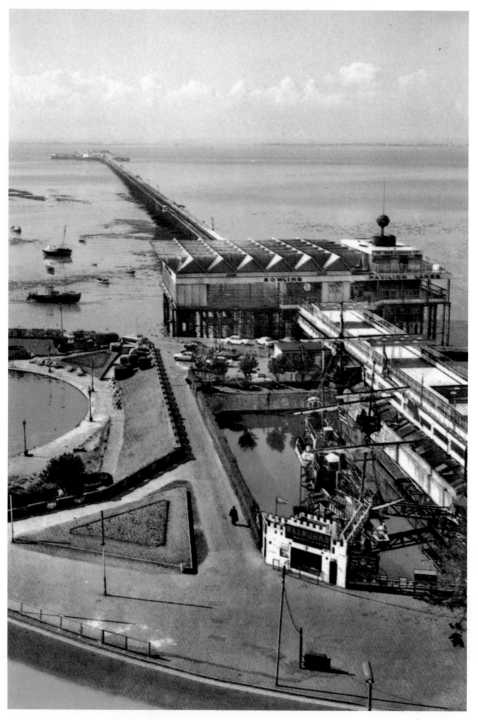

18 A view that will be familiar to any visitor to Southend during the 1960s. It shows the replacement shore-end bowling alley that replaced the pavilion destroyed by fire. It was opened in 1962. At the bottom of the image is the well-loved galleon attraction – the 'Golden Hinde' and its adjacent gruesome Spanish Inquisition waxworks.

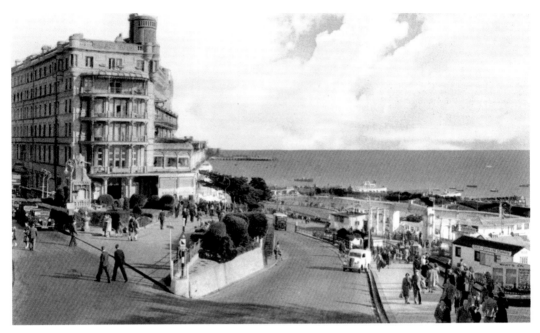

19 Most visitors to Southend will remember struggling up the steep incline at Pier Hill. This view shows the entrance to the pier on the right along with the booking office for the Eagle & Queen Line. On the left-hand-side is the imposing Palace Hotel of 1901.

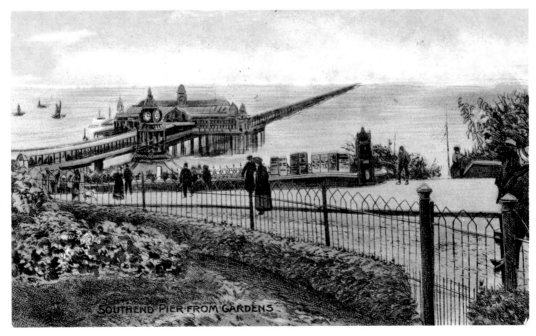

SOUTHEND PIER FROM GARDENS

20 A view of Pier Hill at Southend during Edwardian times. At the time, the area appears to be less commercialised than in later years. Posters are shown advertising paddle steamer cruises. The pier has always been the most famous feature of Southend.

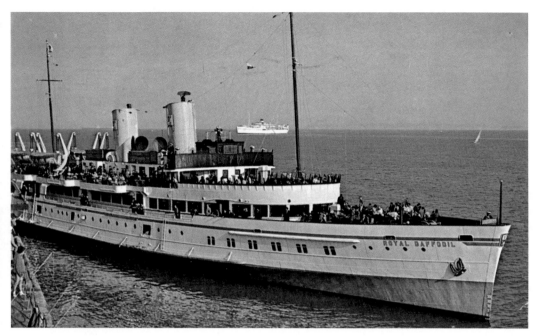

21 *Royal Daffodil* at Southend Pier. Sir John Betjeman once said that, 'The pier is Southend, Southend is the pier'. He had a great love of heritage and later became Patron of the charity that later operated the *Waverley* and *Balmoral* from Southend Pier.

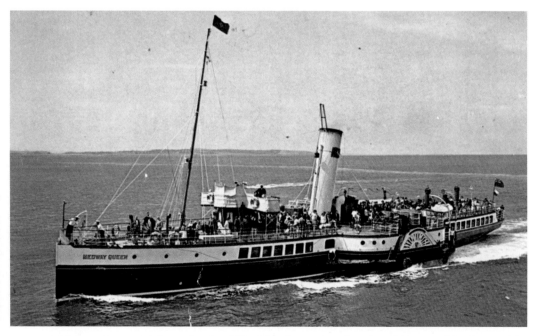

22 *Medway Queen* arriving at Southend Pier. The pier re-opened to the public on 27 March 1945. The immediate post-war years saw the pier re-gain all of its inter-war popularity. Around 1.5 million people visited the pier to enjoy its attractions each year at this time.

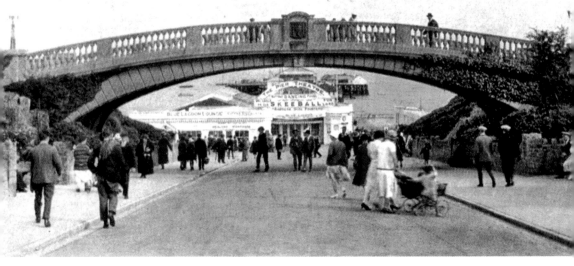

23 Clacton Pier was purchased by Ernest Kingsman in 1922. It remained in the ownership of his family until the early 1970s. During their tenure, the pier experienced its heyday.

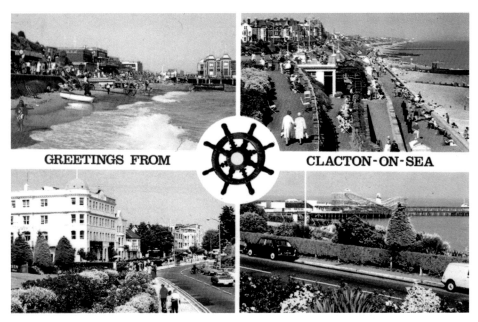

24 Clacton never gained the popularity of Southend. Its main feature was, of course, its fine and widely developed pier. The resort was further enhanced by its fine cliff-top walks, pleasant promenades and cliff-top hotels.

25 *Waverley* alongside the berthing arm at Clacton around 1997. Post-war visitor figures had never returned to their pre-war high. Rival resorts such as Southend, with their more developed range of facilities, managed to hang onto their popularity for several more years. By the time that *Waverley* and *Balmoral* arrived, landing facilities were showing their age.

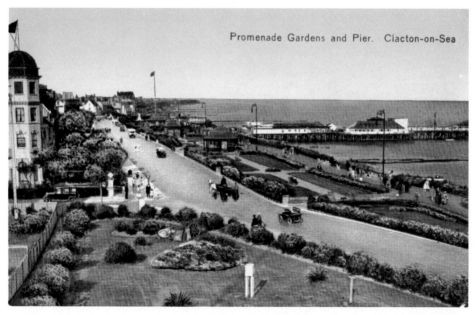

Promenade Gardens and Pier. Clacton-on-Sea

26 Clacton Pier had an enormous open-air swimming pool that was situated on the pier. The pool was said to be the largest pool situated over the ocean in the world. It included underwater illuminations, a café and a sun deck.

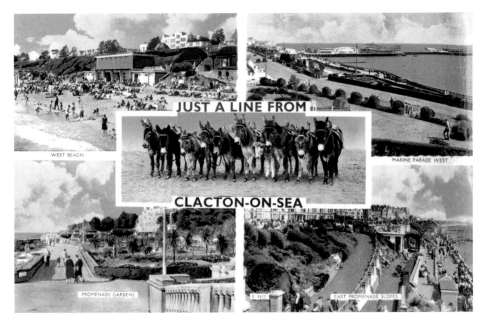

27 Billy Butlin opened his famous holiday camp at Clacton in the mid-1930s. It remained hugely popular for over thirty years before decline and eventual closure in 1983. Butlins at Clacton was famed for its entertainment. Cliff Richard made his professional debut at the camp in 1958. Other artistes that were discovered there included Des O'Connor and Roy Hudd. Many visitors arrived by pleasure steamer to stay at Butlins.

28 'At the end of the day' – a familiar sight for many Londoners as the *Waverley* departs from Tilbury with the sun setting on her way back home to London. For most passengers, the trip back up to London at night is quite magical as the many riverside landmarks are floodlit. Each seems to be bigger and better than the last until *Waverley* turns the bend in the river and a floodlit Tower Bridge is revealed.

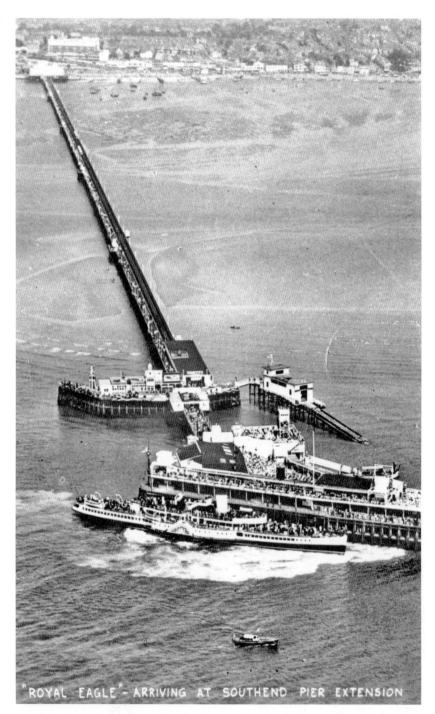

"ROYAL EAGLE" - ARRIVING AT SOUTHEND PIER EXTENSION

Royal Eagle manoeuvring at Southend Pier around 1935. *Royal Eagle* was built at Birkenhead in 1932 and was 290 feet in length. She could carry up to 1,987 passengers at a maximum speed of 18.5 knots. *Royal Eagle* employed some seventy people in its catering department. During the winter, they were employed in large London hotels and restaurants.

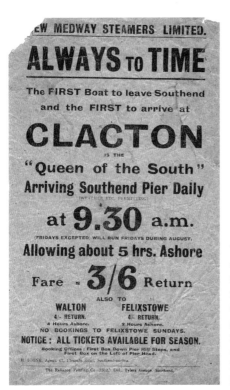

EW MEDWAY STEAMERS LIMITED.

ALWAYS TO TIME

The FIRST Boat to leave Southend
and the FIRST to arrive at

CLACTON

IS THE

"Queen of the South"

Arriving Southend Pier Daily
(WEATHER ETC. PERMITTING)

at **9.30** a.m.

(FRIDAYS EXCEPTED WILL RUN FRIDAYS DURING AUGUST.)

Allowing about 5 hrs. Ashore

Fare = **3/6** Return

ALSO TO

WALTON FELIXSTOWE
4/- RETURN. 4/- RETURN.
4 Hours Ashore. 2 Hours Ashore.

NO BOOKINGS TO FELIXSTOWE SUNDAYS.

NOTICE : ALL TICKETS AVAILABLE FOR SEASON.

Booking Offices : First Box Down Pier Hill Steps, and
First Box on the Left of Pier Head.

H. STONE, Agent, 67, Church Road, Southend-on-Sea.

The Reliance Printing Co. (1912.) Ltd., Tylers Avenue, Southend.

The 1930s saw a great many changes in life for people in the UK. This spread to change the fortunes of pleasure steamers. By this time, the popularity of a pleasure steamer cruise to the seaside wasn't as great as it had been a generation before. Charabancs were becoming more popular and for the rare few, a car was an option. The 1930s therefore saw fleets change. Effective marketing through things such as handbills became even more important.

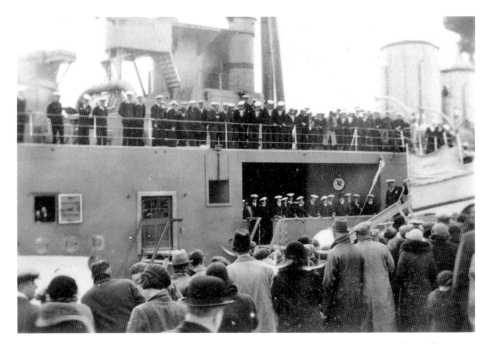

During the 1930s, passengers from Southend often went on a cruise to view warships. They were often allowed to go aboard the battleships and were warmly welcomed by officers and crew, as can be seen here as they prepare to transfer from ship to ship.

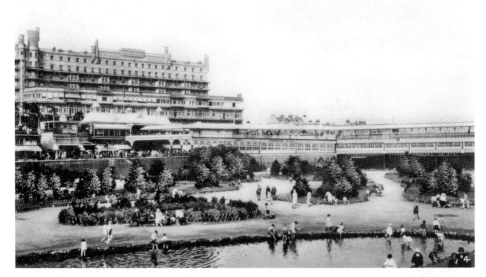

Southend, like the pleasure steamers that visited its pier, had to adapt to changing tastes. The old Sunken Gardens shown here were later to become 'Peter Pan's Playground' as the more sedate pleasure of walking in gardens gave way to the excitement of rides. Along the centre of this view you can see the long station building for the pier railway. This was invaluable for steamer passengers as it was a long walk along the pier to catch the steamer home to London.

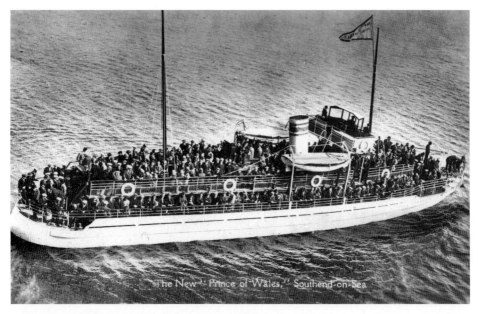

The New "Prince of Wales," Southend-on-Sea

Passengers pack the newly introduced *Prince of Wales* at Southend in 1923. She was quite a large boat and provided local cruises for visitors to Southend. She had a wooden hull and was built by Alec Fowler at Bosham and was 104 feet long. She had a shallow draft and was perfect for undertaking short cruises from a small jetty close to the pier at the beach. *Prince of Wales* ran from the end of the pier at low tides. She was operated by the Southend Motor Navigation Co.

67

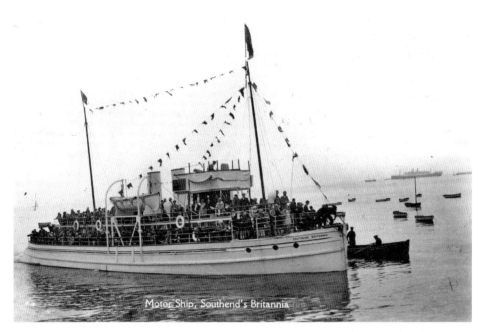

Southend Britannia was a popular local cruise boat and was acquired for Southend service in 1924. She was 106 feet long and was slightly bigger than the new *Prince of Wales*. She was built by John L. Thorneycroft. This had a distinctive slanting stern. She had two funnels, of which the forward was a dummy. *Southend Britannia* was one of the small ships that took part in the Dunkirk evacuation. After the war she served as *Brightlingsea Belle* on the Colne, and later as *Western Lady V* at Brixham.

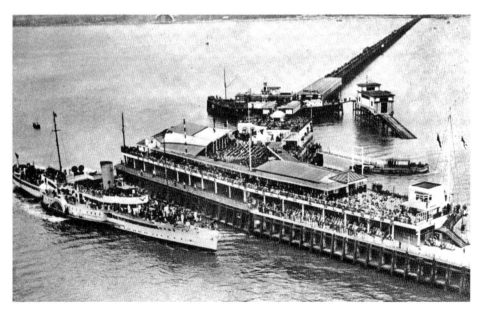

Royal Eagle arriving at Southend Pier. Steamers berthed at the Prince George Extension. This was over 320 feet long and ranged from 30 to 70 feet wide. It was constructed from 4,700 tons of reinforced concrete.

Southend illuminations were a popular attraction for trippers by pleasure steamer to the resort. The extensive displays returned after the Second World War in 1949 and remained a popular attraction for many more years.

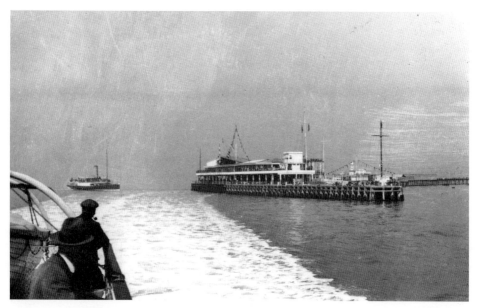

Southend's pier head always provided a lot of activity as pleasure steamers arrived and departed. Here, *Essex Queen* is seen approaching the pier at the time when the Prince George extension had been completed.

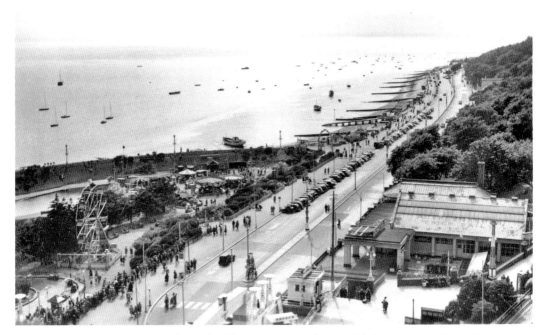

A view from Pier Hill at Southend. On the left is Peter Pan's Playgound. This attraction changed over the years to reflect changing tastes and technology. It once contained features such as a zoo. Several old favourites such as the Crooked House, mine ride and go carts have all survived.

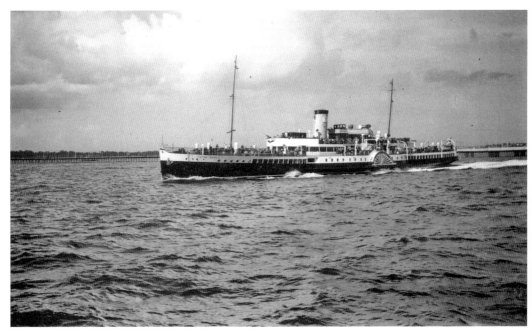

Royal Eagle has just departed from Southend Pier for London in 1947. *Royal Eagle* was the steamer chosen to re-start Thames pleasure steamer services at the end of the Second World War. She made this trip on Victory Day – 8 June 1946.

Life goes with a Swing at Southend.

The steamer guides were positive advertisements for the resorts that the Eagle & Queen Line visited. This is from the 1939 guide.

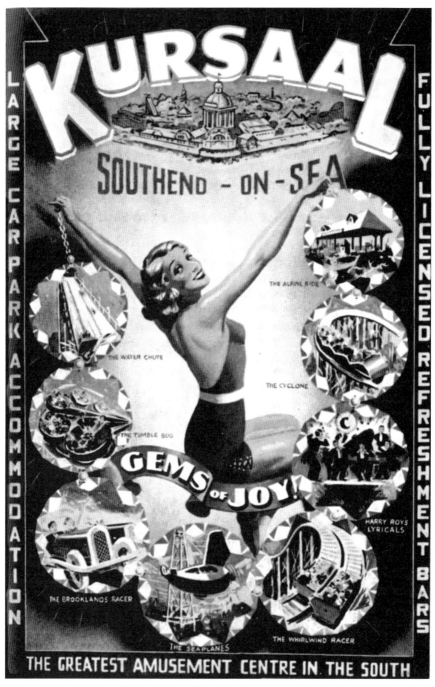

Advertisement for the Kursaal in 1938. The amusement park was a great favourite of steamer passengers, who could easily walk the short distance to it. The Kursaal included a circus, ballroom, amusement arcade, dining hall and billiard room. The Kursaal was very popular in its day. The world's first lady lion tamer and the world's first female wall of death rider performed there. It was also the first place in the UK to display Al Capone's car from Chicago. A popular attraction for many years was Eric the stuffed whale.

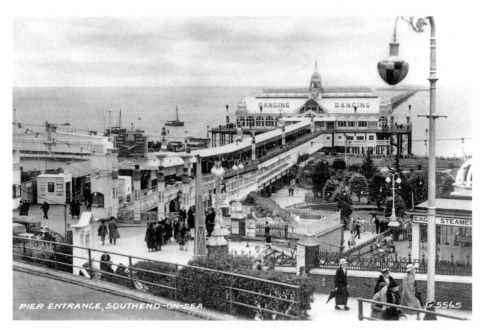

A view of the entrance of Southend Pier around 1930. The Eagle Steamers booking office can be seen on the right-hand side. Passengers alighting from the pier trains were always faced with lots of traditional seaside attractions, pubs and cafes in this area. Almost opposite the pier was Never Never Land. This family attraction looked particularly impressive during the illuminations.

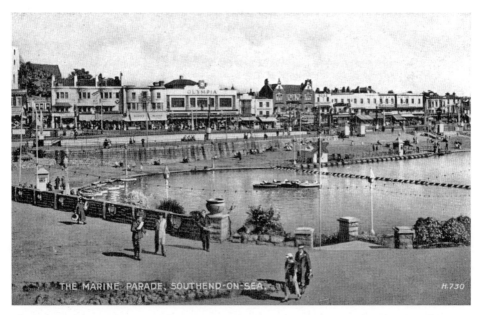

The boating lake to the east of the pier at Southend. It remained a popular attraction for many years until tastes changed during the 1970s. It later became the extension to the amusement park on the other side of the pier. On the left of the image on Marine Parade is the famous Rossi ice cream parlour. This was the original shop operated by the family.

On and after 14th JULY until further notice

The Superb New T.S.M.V.

"ROYAL SOVEREIGN"

WILL SAIL from SOUTHEND PIER as follows

SUNDAYS at **10** a.m. THURSDAYS at 9.45 a.m.	On SUNDAYS and THURSDAYS 7 HOURS ASHORE AT **MARGATE** 3 HOURS ASHORE AT **CALAIS**	DAY RET'N FARES **MARGATE 5/-** *(Child 2/6)* **CALAIS** **10/6** *(Child 6/-)*
At **9** a.m.	On TUESDAYS 8 HOURS ASHORE AT **MARGATE** 3 HOURS ASHORE AT **BOULOGNE**	**MARGATE 5/-** *(Child 2/6)* **BOULOGNE** **11/6** *(Child 6/-)*
At **8.30** a.m.	On MONDAYS, WEDNESDAYS and SATURDAYS 10 HOURS ASHORE AT **MARGATE** 3 HOURS ASHORE AT **OSTEND**	**MARGATE 5/-** *(Child 2/6)* **OSTEND** **12/-** *(Child 6/6)*

FOR FULL TIMES and FARES, etc., SEE REVERSE SIDE

N.B.—Southend/Margate passengers returning by this steamer are subject to examination by H.M. Customs.

Sailings are subject to weather and other circumstances permitting. Passengers are only carried upon the terms and conditions printed upon the N.M.S.P. Co's Tickets.

EXCELLENT LUNCHEONS, TEAS & LIGHT REFRESHMENTS ON BOARD

BOOK on the PIER
or at "EAGLE" and QUEEN LINE STEAMERS, PIER HILL
SOUTHEND-ON-SEA Phone: 67095 Marine

3rd July, 1937. Borough Printing & Publishing Co., 63a Southchurch Road, Southend-on-Sea. P.T.O.

Handbill for cruises by the new *Royal Sovereign* in 1937. *Royal Sovereign* was a great step forward for Thames pleasure steamers. Her arrival signalled a revolution in design and features. Southend passengers were able to purchase their tickets at the Eagle & Queen Line office on Pier Hill.

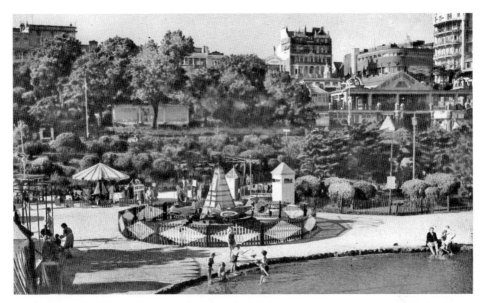

Peter Pan's Playground was a well-loved landmark for several generations of child visitors to Southend. With its proximity to the pier, it was a natural place to visit for children. One of the most popular rides was the 'Gold Mine' with its tubs that spun children inside the dark tunnels.

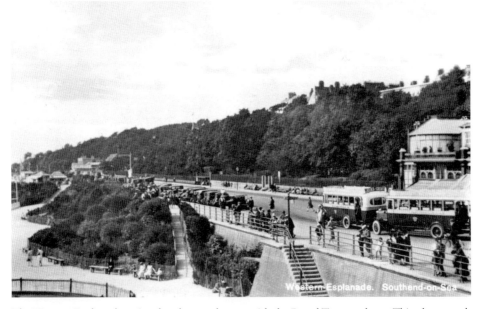

The Western Esplanade at Southend around 1930 with the Royal Terrace above. This photograph was taken at the shore end of the pier and shows how much motor cars and charabancs were affecting the pleasure steamer business.

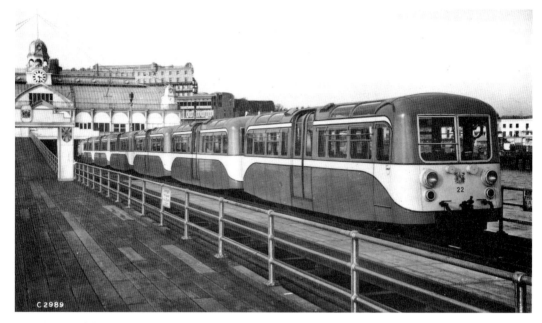

Generations of daytrippers to Southend will remember with great fondness the green and cream pier trains. With their comfortable and roomy accommodation, they carried millions of passengers along the pier to the waiting pleasure steamers. Sadly, by the 1970s, the post-war boom had disappeared and the trains were scrapped or sold for preservation.

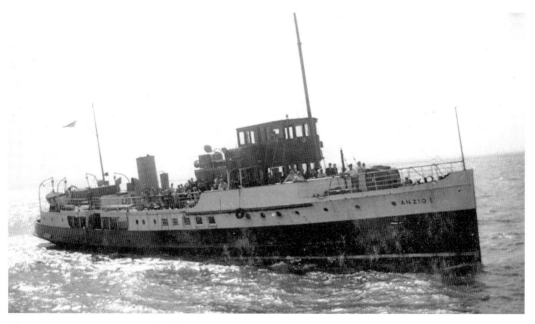

The *Anzio I* arriving at Southend Pier in August 1962. She operated between Southend Pier and Sheerness. She landed her passengers at the Captains Steps at the former RN Dockyard at Sheerness. She could carry up to 351 passengers and was later withdrawn. *Anzio I* was sadly lost while being towed to a new future at Inverness.

Southend illuminations started in 1935. By the mid-1950s, the pier alone had fifty-eight tableaux and set pieces displayed upon it. Over 35,000 lamps were used to illuminate these.

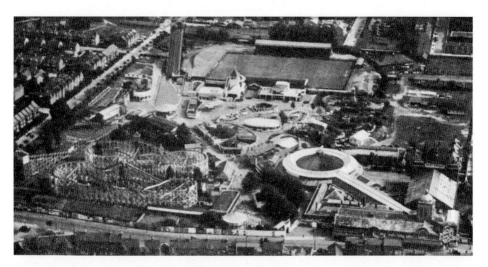

The Kursaal was famous for its traditional fun rides. Favourites included the Cyclone, Water chute, Caterpillar and the Wall of Death. The Caterpillar was a particular favourite with Londoners. Passengers sat in seats and went up and down as the ride revolved. All of a sudden, a cover would cover the passengers and they were then exposed to a fan blowing from below. This appealed in particular to fun loving women passengers who suddenly found a cool breeze!

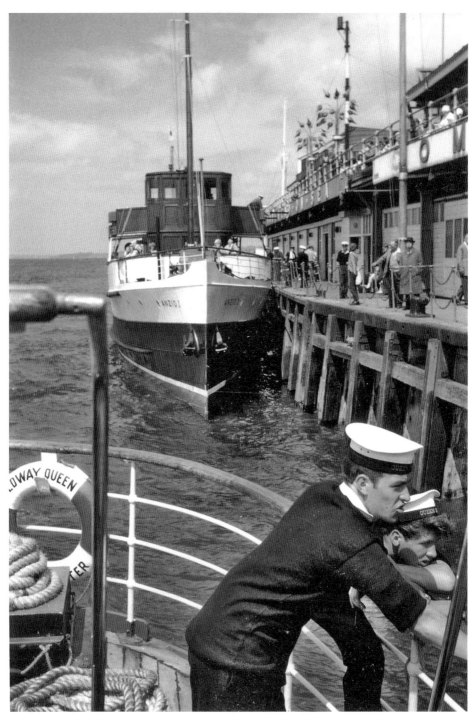

A scene that sums up the atmosphere of Southend Pier. Two young seamen aboard the *Medway Queen* are observing the berthing of their steamer while the *Anzio I* remains alongside the Prince George Extension. The pier head buildings can be seen alongside the steamers. With the loss of the *Medway Queen* in 1963, the three Thames motor ships soldiered on alone on their visits to Southend.

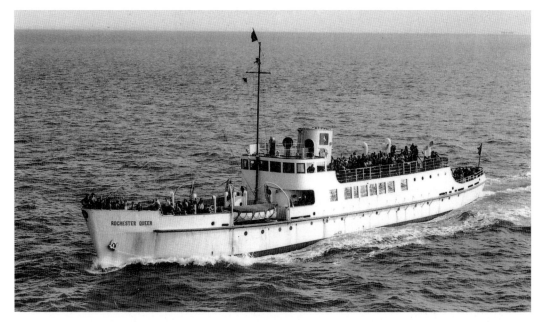

Rochester Queen offered popular cruises from Southend Pier in the early 1950s. She had been built in 1944 and was 147 feet in length and was registered by the New Medway Steam Packet Company. *Rochester Queen* became known for the Strood, Southend and Herne Bay route.

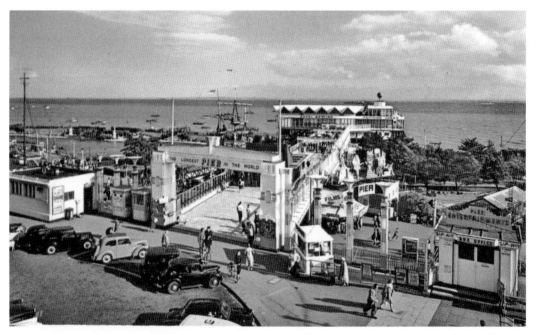

During the 1940s and 1950s, the only way to get to France for most folk was aboard one of the three Eagle Steamer pleasure steamers. Passengers departed from Southend Pier at 10.00 a.m. and arrived at Boulogne at 2.00 p.m. At the time, you could get a day return ticket from Southend for £1 15 shillings. After three hours ashore, you would return home by steamer and arrive at Southend at 9.00 p.m.

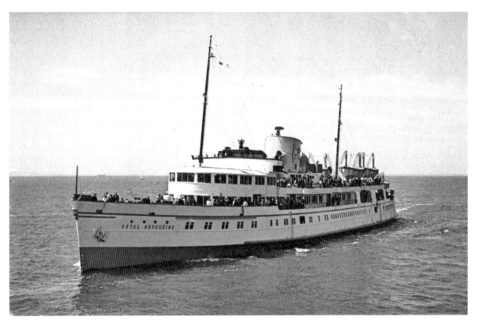

Royal Sovereign arriving at Southend Pier from London. Built as a replacement for her namesake that was lost during the war, *Royal Sovereign* could carry up to 1,783 passengers. She had fine facilities, such as two dining saloons capable of seating 140 and 96 passengers. She was ideal for the immediate post-war boom but her size meant that ultimately, she would be too large and uneconomic.

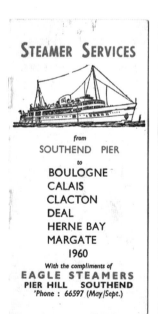
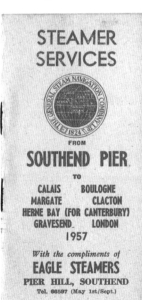
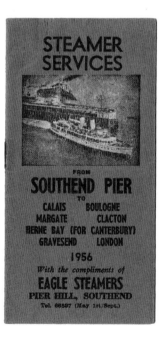

Eagle Steamers produced pocket guides for their services from Southend Pier. These opened out to give simple information on dates, timings and fares for cruises from the Essex resort.

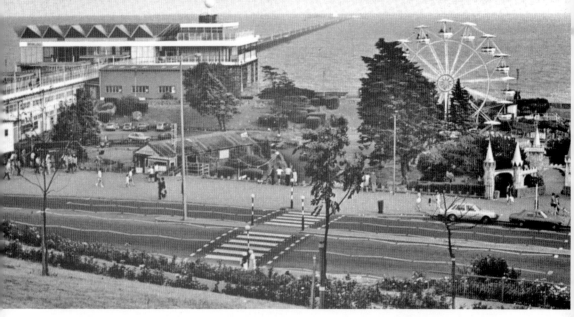

Southend Pier had trains that travelled out to the pier head for pleasure steamer passengers. Trains were vitally important as the pier's success was dependent on trains to get people from the shore to the pier head. The well-loved green and cream 1949 pier trains cost £99,100. Their arrival was very important as the pier was enjoying a post-war boom as Londoners who had survived the Blitz were enthusiastic to have a day at Southend again. This fleet operated from 1949 until 1978.

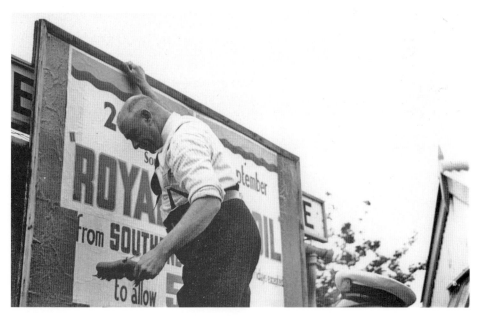

A bill poster gets ready for the season by pasting an Eagle Steamers poster onto an advertising hoarding during the 1950s. It advertises cruises from Southend.

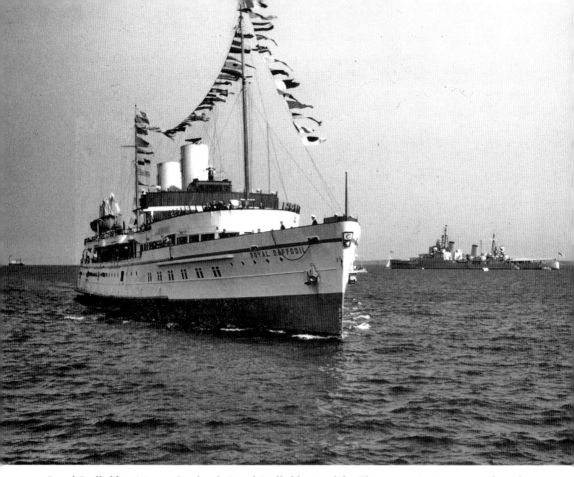

Royal Daffodil arriving at Southend. *Royal Daffodil* arrived for Thames service in 1939 and got her name from the ex-Mersey ferry. She was to become the epitome of River Thames style. It was suggested that a better name for her would have been *Queen of the South*. She was around 300 feet in length and was more than twice the tonnage of her sister, the *Queen of the Channel*. After an illustrious career in the Second World War, during which time she was damaged at Dunkirk, she was reconditioned and returned to service in 1947. She became famous for her Gravesend to Southend, Margate and the French coast cruises during the 1950s. Landing trips to Boulogne and Calais weren't allowed until the mid-1950s due to security reasons.

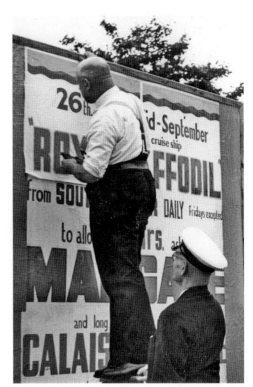

A poster for the *Royal Daffodil* being pasted onto a hoarding advertising cruises from Southend Pier to Margate and Calais during the 1950s.

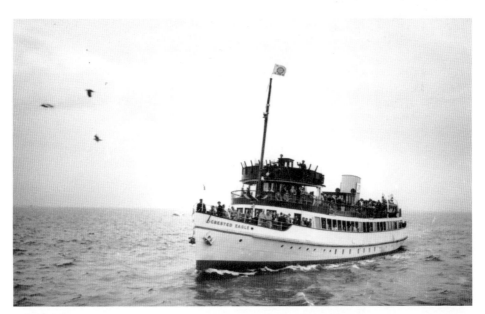

Crested Eagle approaching Southend Pier She was part of the Eagle Steamer fleet during the post-war years. She was the former *Royal Lady* from Scarborough and was 144 feet in length. She had a fine reputation for her cruises to view shipping in the Royal Docks. She also operated trips from London Tower Pier to Gravesend and Southend.

Passengers aboard an Eagle Steamer on a cruise from Southend Pier around 1950. At his time, Eagle Steamers were looking at changing their fleet. They were contacted by the well-known operators P&A Campbell to see whether the *Royal Eagle* or *Golden Eagle* could be stationed on the Sussex coast but this came to nothing.

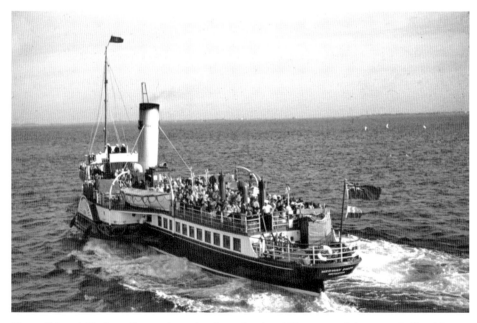

The well-loved *Medway Queen* departing from Southend Pier on 30 July 1963. Sadly, this was one of the last times that the *Medway Queen* could be viewed in this way as she was withdrawn little more than a month later. Fifty years later, *Medway Queen* was rebuilt with the aim of returning her to service.

From 9th JUNE until 8th SEPT., 1962
Every SATURDAY (except 23rd JUNE)
p.s. **'MEDWAY QUEEN'**

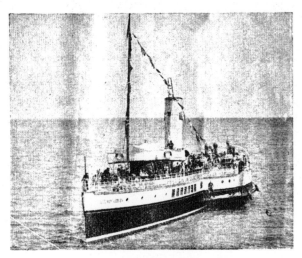

Sails from **SOUTHEND PIER**
at **11.30** a.m.
for a grand cruise UP THE RIVER MEDWAY *to* STROOD
allowing up to **2¼** hours in the

HISTORIC CITY OF ROCHESTER

An excellent opportunity to visit Rochester Cathedral and Castle,
which are situated within walking distance from Strood Pier

DAY 9/6 RETURN

SINGLE **PERIOD RETURN**
7/- 12/6

CHILDREN: under 14 yrs. half fare—under 3 yrs. free

TIMES

Depart SOUTHEND 11.30 a.m.	**Depart STROOD 3.30 p.m.**
Due STROOD 1.10 p.m.	**Due SOUTHEND 5.10 p.m.**

Sailings are subject to weather and other circumstances permitting
FOR CONDITIONS OF CARRIAGE SEE OVERLEAF

BOOKING—in advance or on day of Sailing, at

EAGLE & QUEEN LINE STEAMERS

PIER HILL, SOUTHEND-ON-SEA Telephone: 66597 (May/Sept.)

During 1962, *Medway Queen* offered cruises across to the River Medway. She landed passengers at Strood Pier. They were then able to walk across Rochester Bridge for a look around Rochester before returning home.

Medway Queen has just arrived at Southend Pier on 30 July 1963. During the final 1963 season *Medway Queen* was under the command of Leonard Horsham. Mr Ruthven was the Chief Engineer. At the time, she operated from Strood to Southend and Herne Bay and sometimes onto Clacton.

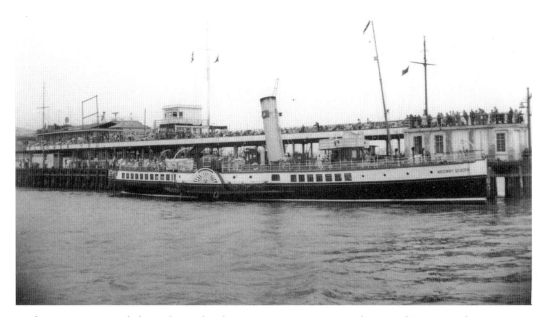

Medway Queen moored alongside Southend Pier on 1 August 1961. At the time, things were changing for the *Medway Queen*. She was an elderly steamer and needed a great deal of money for work to keep her sailing further into the 1960s.

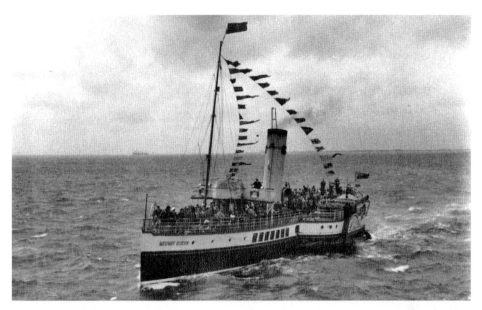

Medway Queen made her final trip to Southend on 8 September 1963. Cheering, singing, civic receptions and plenty of flag waving and streamers marked her final call from her Essex home of forty years.

The Promenade, Southend-on-Sea 27349

Most pleasure steamer visitors to Southend have enjoyed a Rossi ice cream! The family started trading at Marine Parade and Western Esplanade during the early 1930s. The 1950s and 1960s saw Rossi flourish from their seafront premises close to the pier. The family became famous for serving their traditional vanilla ice cream served from stainless barrels using the 'spoon' to serve the ice cream onto the cone.

NEW BELLE STEAMERS

ANNOUNCE A SERIES OF SPECIAL SEPTEMBER

Sea Cruises from Southend

BY THE FAMOUS PADDLE STEAMER 'CONSUL'

Meals & Refreshments served in comfortable saloons at very reasonable prices. Music on Board

FULLY LICENCED BAR OPEN ALL DAY

Tuesday **17th** September	AT 12.15pm. Arr.Back App. 6.30 pm	**Day return to HERNE BAY** Allowing over 2 hours ashore. Passengers may also remain on board for special cruise from Herne Bay.	Day Return ONLY 9/6 Inc: Sea Cruise 14/-
	AT 6.30 pm.	**Single trip to GRAVESEND** Ample time to return by train & ferry to Southend.	Single Fare 4/6
Wednesday **18th** September	3.45pm. Returning At App: 5.10pm.	**Delightful Afternoon Sea Cruise** To view the River Medway, Kentish Coast, Isles of Grain & Sheppey.	REDUCED Return Fare 4/-
	AT 5.15pm. Arriving Back About 9.00pm	**Musical SHOWBOAT Cruise** Special Evening Up River to **Gravesend and Tilbury** A wonderful opportunity to view the Illuminations. BAND ON BOARD NON LANDING	Return Fare 8/6
~~Thursday~~ **19th** September	AT 2.35pm Returning 4.15pm	**Afternoon Sea Cruise** To view the Essex Coast, passing Shoeberryness Foulness & the Maplin Sands.	MIDWEEK Return Fare 4/-
	AT 4.15pm	Single trip to **Greenwich & London** Ample time to return by train to Southend.	Single Fare 6/-
Friday **20th** September	AT 12.15pm Returning App: 6.30pm	**Day return to HERNE BAY** Allowing over 2 hours ashore. Passengers may also remain on board for special cruise from Herne Bay.	Day Return ONLY 9/6 Inc: Sea Cruise 14/-
	AT 6.30pm	**Single trip to GRAVESEND** Ample time to return by train & ferry to Southend.	Single Fare 4/6
Saturday **21st** September	2.35pm Returning App: 3.40pm	**Afternoon Sea Cruise** Around the Estuaries of the Thames & Medway	Return Fare 4/-
	AT 3.45pm	Single Trip to **Greenwich & London** Ample time to return by train to Southend.	Single Fare 6/-
Final Sailings Sunday **22nd** September	2.35pm Returning App: 4.15pm	**Afternoon Sea Cruise** Up the Thames & over to the Medway to view Allhallows Canvey Island Shellhaven etc:	SPECIAL Return Fare 5/-
	AT 4.15pm	Single trip to **Greenwich & London** Ample time to return by train to Southend.	Single Fare 6/-

All sailings subject to weather & circumstances permitting. Passengers are only carried on the terms & conditions printed on the back of the ticket. Tickets available on the Steamer

Southend Pier welcomed many pleasure steamers over the years. Many of these are now forgotten. The charming little *Consul* only visited Southend for a week in September 1963. *Consul* spent most of her career working for Cosens of Weymouth. After being withdrawn, she operated a short season of cruises for New Belle Steamers. This wasn't a success and Southend never saw *Consul* again.

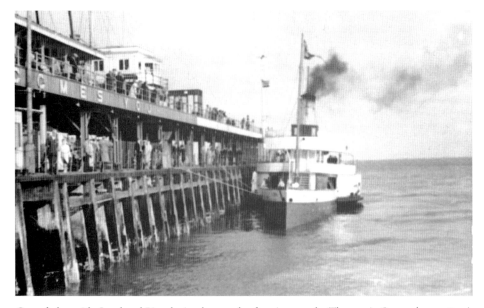

Consul alongside Southend Pier during her week of cruises on the Thames in September 1963. A few years earlier, in 1959, a fire destroyed the pavilion located at the shore end of the pier. Over 500 people were trapped on the other side of the fire and had to be rescued by boat. The pavilion was replaced by a bowling alley in 1962.

Consul is lying alongside the pier at Southend in September 1963. This steamer had a long and distinguished career. Originally built on the Thames, she spent most of her career cruising along the Dorset coast. Her modest size made her quite economic for operating but she needed money spent on her as she was old.

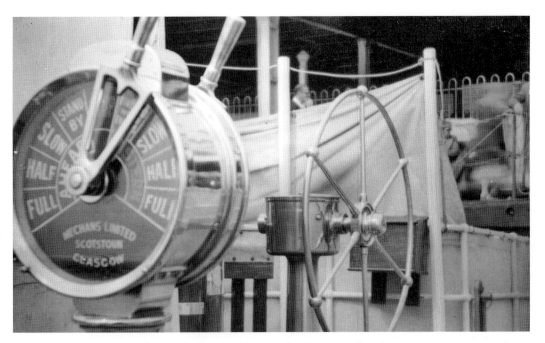

A rare view of *Consul's* open bridge. By this time, the pier's usage by pleasure steamers was starting to decline. This was mirrored by the town itself, which slowly declined after being affected by the move towards Continental holidays and the rise of the motor car.

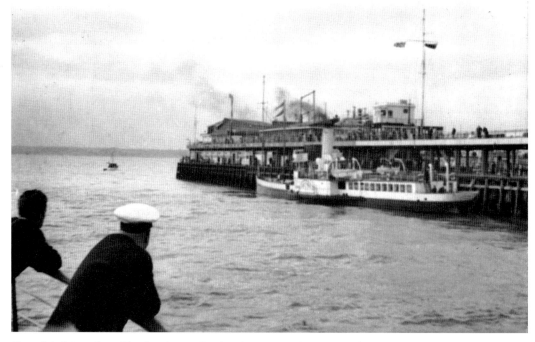

Consul is lying alongside the pier at Southend in September 1963. This steamer had a long and distinguished career. Originally built on the Thames, she spent most of her career cruising along the Dorset coast. Her modest size made her quite economic for operating but she needed money spent on her as she was old

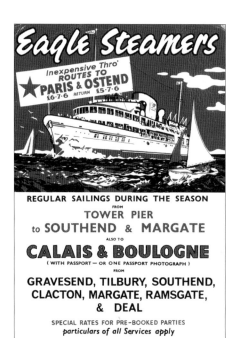

A poster from 1963 advertising services from London's Tower Pier to Southend and France. *Queen of the Channel*, *Royal Sovereign* and *Royal Daffodil* were splendid vessels and offered passengers vast sun lounges as well as ample open deck space.

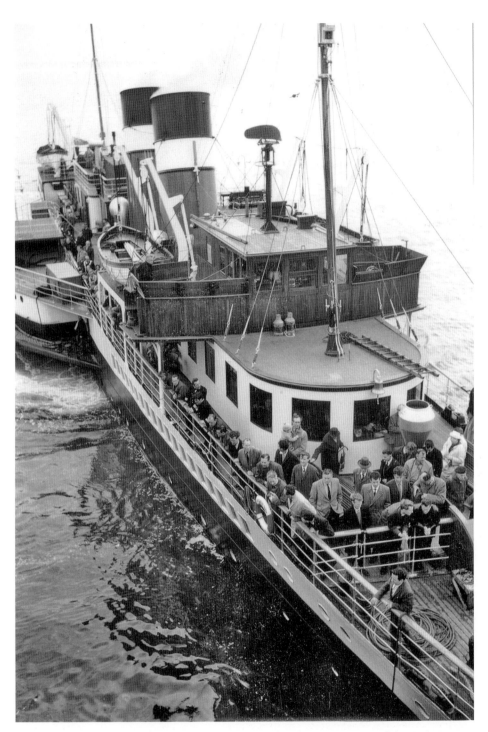

Queen of the South alongside Southend Pier in 1966. The pleasure steamers of the Eagle Steamer fleet stopped their services to Southend during the mid-1960s. This was around the time when the *Queen of the South* visited. Although in decline for many years, the full withdrawal of steamers meant that the number of visitors using the pier dropped dramatically.

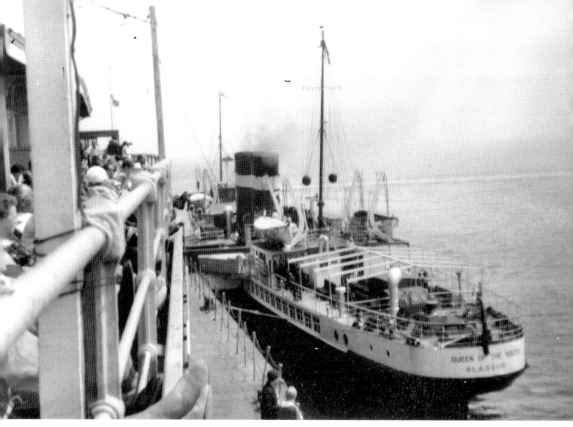

Queen of the South at Southend on 1 July 1967. Despite being a failure on the Thames, the steamer introduced many new attractions to tempt passengers. These included a seafood bar and a 'melotone' music maker. Southend often became the last calling point for *Queen of the South* passengers when the steamer broke down and passengers had to return to London by train. Around £50,000 had been spent on the renovation of the *Queen of the South*. During the winter of 1966, further money was spent on her. This included the fitting of a bow rudder. Her following season became even more of a failure and her fate was sealed when a writ was attached to her mast. It was a sad but inevitable end for a well-loved Firth of Clyde paddle steamer.

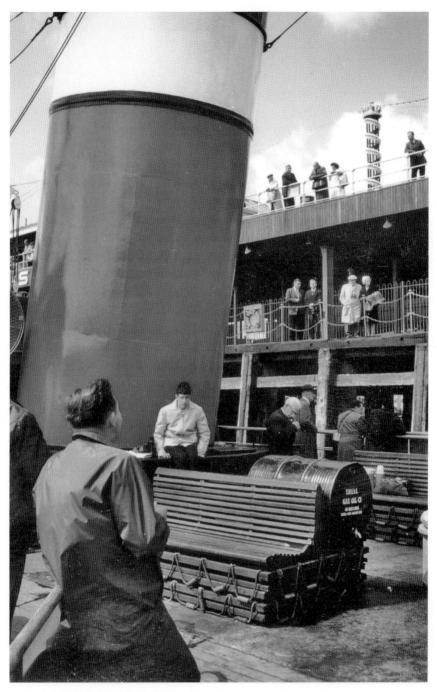

Queen of the South lies alongside Southend Pier in 1966. The pier head was always busy with a pleasure steamer arriving or departing. The pier must have looked quite a sight when it was festooned with illuminations at night.

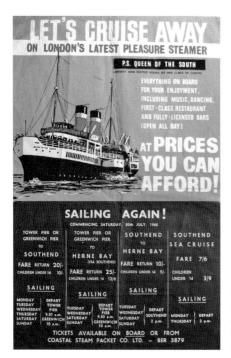

A striking poster for the *Queen of the South* on the River Thames during the mid-1960s. Her operators made a huge effort to make her a success. The quality of the publicity material as well as features of the steamer reinforces this.

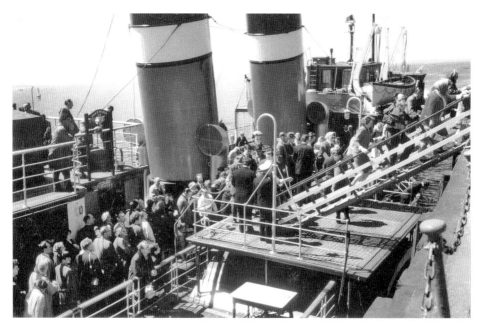

A view familiar to millions of daytrippers from London as passengers queue to disembark from the *Queen of the South* at Southend Pier in 1966. Southend, with its amusements, pubs and beach, was a huge magnet for Londoners. Many of these would spend the entire cruise from London to Southend in the bar. After a drink or two, many would almost miss the chance of disembarking at the pier. They then had to make a quick dash to disembark before the gangway was removed!

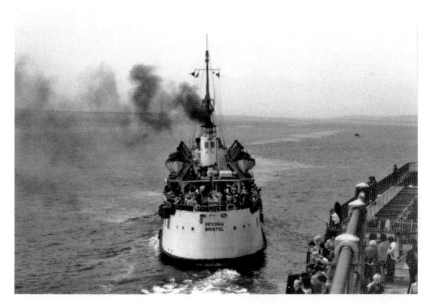

Devonia departing from Southend Pier in 1977. Sadly, on 29 July 1976 almost all of the pier head buildings were destroyed in a massive fire and the wooden structure of the pier head was severely damaged. The following few years became the saddest in the history of the pier. A total of £1.4 million of damage was caused by the 1976 fire.

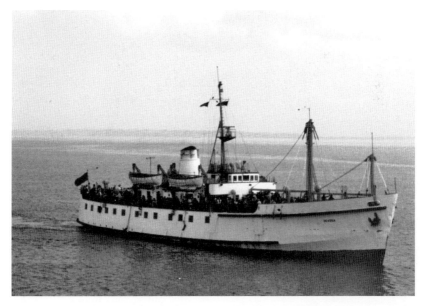

Devonia approaching Southend Pier in 1977. The 1970s were the worst decade for pleasure steamers as virtually no large ships were available to offer traditional day trips to the sea for Londoners. This inevitably led to the decline of Southend Pier. The massive fire of 1976 seemed to be the final nail in the coffin for Thames pleasure steamer services. During the 1976 pier head fire, over 400 gallons of water were used to extinguish the fire by a local aerial crop sprayer aircraft.

Waverley's arrival at Southend brought with it the return of steam. Her massive steam engine was a great attraction for passengers.

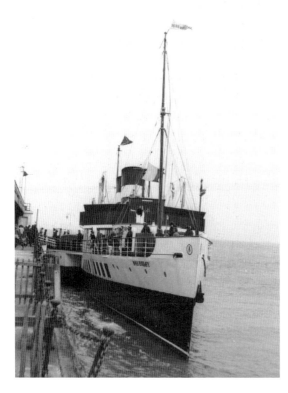

Waverley spent her main career on the Firth of Clyde. By 1978 she was making her first trips south of the border. The River Thames and Southend Pier became a regular calling point from that time. Her September and October sailings have enabled her to earn revenue outside of the limited summer season on the Firth of Clyde. It has also become a tradition to take a cruise on the *Waverley* each autumn.

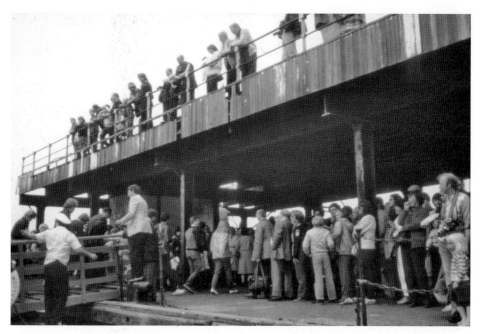

Waverley at Southend Pier during one of her early cruises to the Thames. *Waverley* visited the Thames for the first time in 1979. After more than a decade without a visiting paddle steamer, *Waverley* enabled Londoners to relive happy days of the past by cruising from London to their favourite seaside resort of Southend. Since that time, *Waverley* has made regular calls each October.

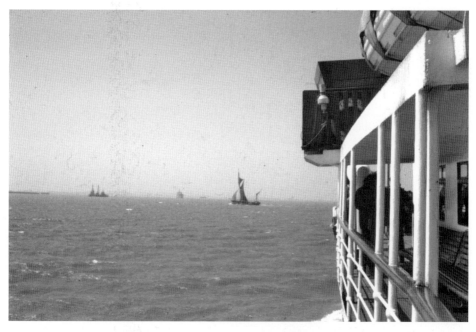

Waverley is cruising on the River Medway in 1980. The Thames sailing barge *Cabby* is in the distance.

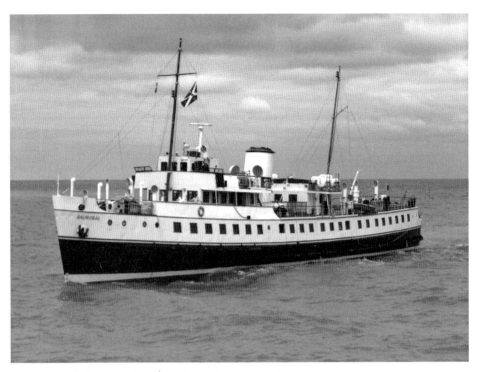

Balmoral made her first visit to Southend Pier in 1987. She's the fleet mate of the *Waverley* and was originally built for service on the Isle of Wight.

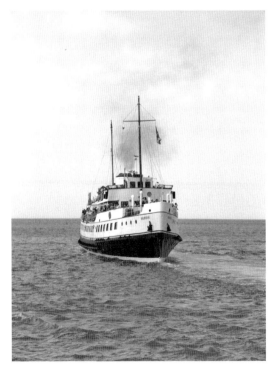

Balmoral departing for Southend after a cruise to Whitstable in July 2011.

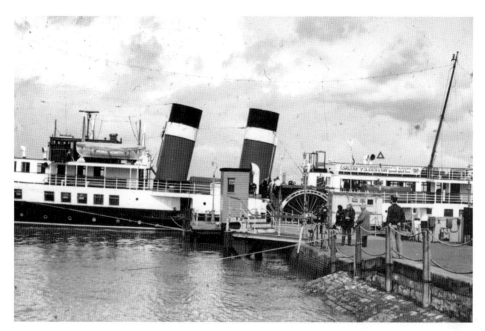

Waverley at Gillingham Pier on one of her early visit to the River Thames. Over more than three decades of visiting the Thames, *Waverley* has called at many piers that can no longer be used. This image shows a rare call at Gillingham for Southend passengers. *Balmoral* has also visited some little-known Essex and Suffolk wharves and rivers on cruises from Southend. These have included visits to Wivenhoe and Mistley.

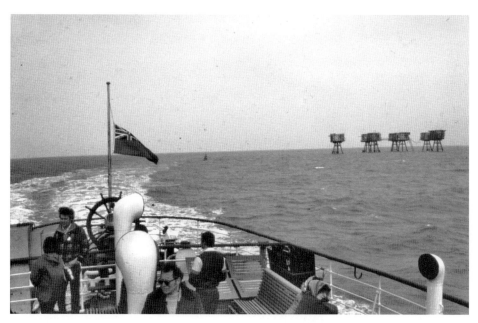

A favourite cruise for many passengers from Southend Pier is the trip to the Thames forts. The fascinating wartime forts, named Red Sands Towers and Shivering Sands Towers, make an interesting destination as the forts are so remote and have such an interesting history.

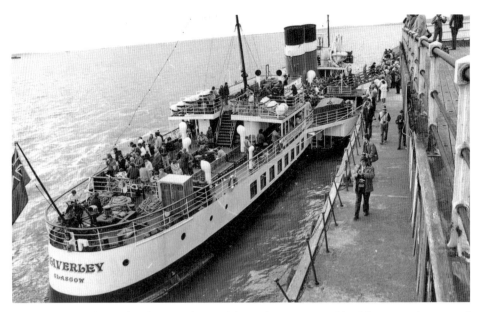

Waverley alongside Southend Pier and viewed from above on one of her Thames cruises around 1990. After years of decline, Southend Council announced that the pier was to close in 1980. Strong protests by locals and visitors alike led the council to allow the pier to remain open until a solution could be found. In 1983, the Historic Buildings Commission gave a grant to allow repairs to be made. The work commenced in 1984 and was completed eighteen months later.

Waverley cruising in the English Channel on 12 July 1980. During her early years on the Thames, *Waverley* was able to travel towards the French coast as well as calling at piers now lost such as Deal.

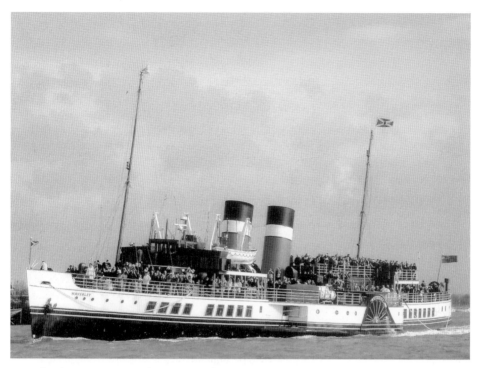

Waverley during a cruise to the River Medway in 2007.

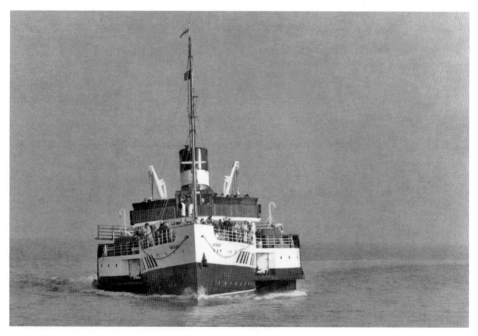

Waverley approaching Southend Pier on 22 September 1986 after a Thames Estuary cruise. *Waverley*'s visits to the Thames commenced after the pier head fire of 1976. The fire-damaged Prince George Extension has been restored since that time to provide full landing facilities.

The *Clyde* was a popular visitor to Southend Pier for many years in the late 1980s and early 1990s. She operated regular weekday and Sunday cruises between Strood and Southend.

INVICTA LINE CRUISES LTD

MV CLYDE

SEASON 1992

Unit B18, Laser Quay, Culpeper Close
Medway City Estate, Strood,
Kent ME2 4HV

Tel: (0634) 723619 (Office Hours)
Fax: (0634) 724012
Answering machine when office closed

Clyde's cruises offered up to seven hours ashore. She could carry up to sixty-five passengers and the return fare was £6.50. Special sailings were also offered to events such as the 'Sweeps Festival', 'Dickens Festival' and the 'Southend Air Show'.

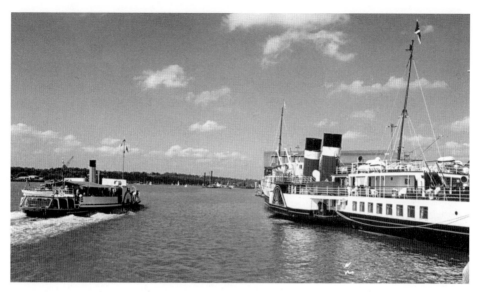

Waverley and *Kingswear Castle* at Chatham Historic Dockyard in May 1994. *Waverley* had cruised from Southend. She tied up alongside the dry docks to allow her passengers time ashore at the Historic Dockyard.

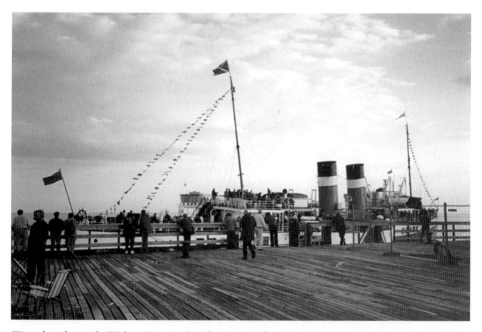

Waverley alongside Walton Pier in October 1996 after she had cruised to the resort with her Southend Pier passengers.

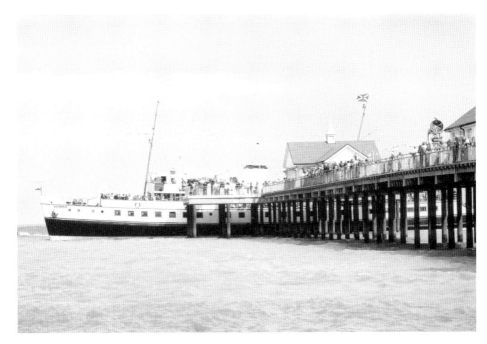

Balmoral alongside Southwold Pier in 2005. The rebuilding of Southwold Pier began in 1999 after many years of decline. The pier was opened by HRH the Duke of Gloucester on 3 July 2001. In February 2002, the berthing section was completed and made the pier 623 feet in length.

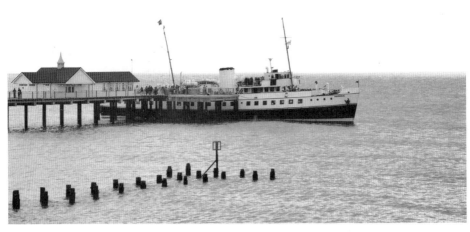

Balmoral at Southwold Pier around 2005. *Balmoral* is the UK's most flexible and adaptable pleasure steamer. Since starting her preservation career in 1986 she has visited most river and harbours in the UK. One of the highlights of her Thames career was the cruise to mark the centenary of Tower Pier in 1994.

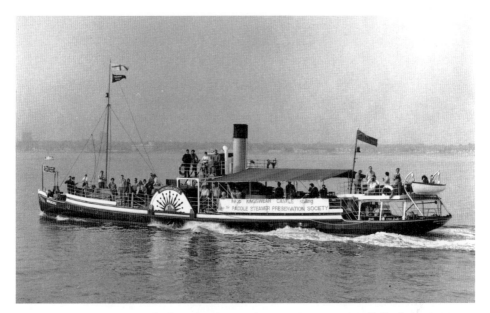

Kingswear Castle cruising off of Southend around 1986. She was originally built for service on the River Dart in Devon. She was restored on the River Medway. This restoration took over fifteen years to complete.

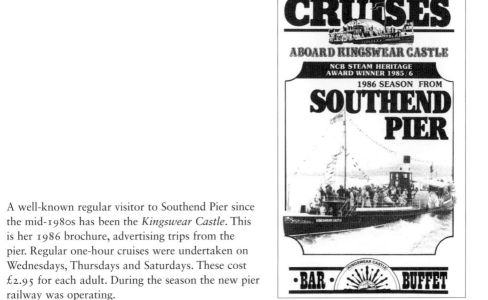

A well-known regular visitor to Southend Pier since the mid-1980s has been the *Kingswear Castle*. This is her 1986 brochure, advertising trips from the pier. Regular one-hour cruises were undertaken on Wednesdays, Thursdays and Saturdays. These cost £2.95 for each adult. During the season the new pier railway was operating.

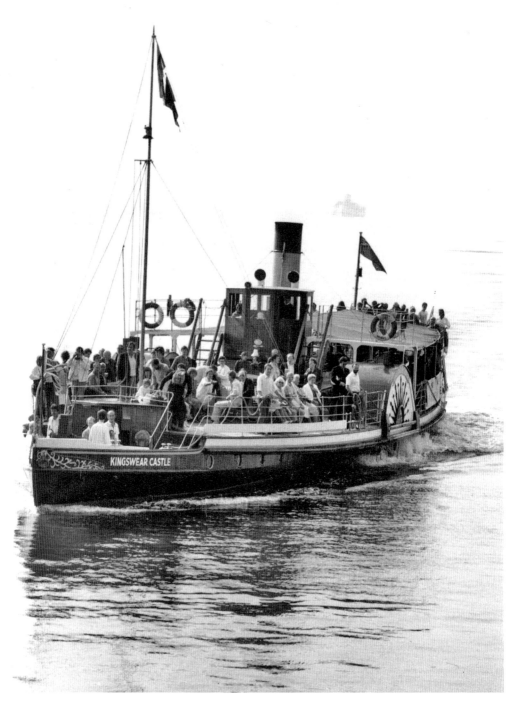

Kingswear Castle initially offered cruises from the pier head at Southend. After a few years, she was able to carry passengers across from Chatham to give them a full day cruise. She has also undertaken cruises into Leigh Creek.

Balmoral alongside Southend Pier in 2002. Around this time, a new building was erected adjacent to the landing arm to house the shop, visitor centre and stores for the RNLI at Southend.

The Thames wartime forts viewed during *Waverley*'s cruise from Southend in 2011.

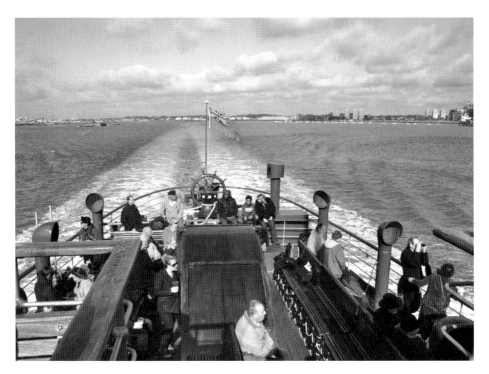

Waverley on a cruise to London in 2009.

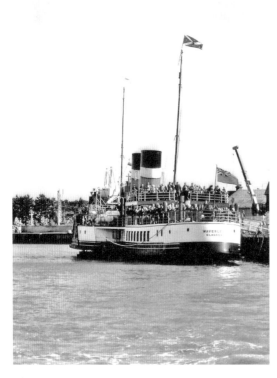

One of the most popular cruises from Southend Pier by the *Balmoral* and *Waverley* is to the quaint fishing port of Whitstable in Kent. *Waverley* is disembarking her passengers in this 2003 view.

Chapter 3

Clacton & Its Pleasure Steamers

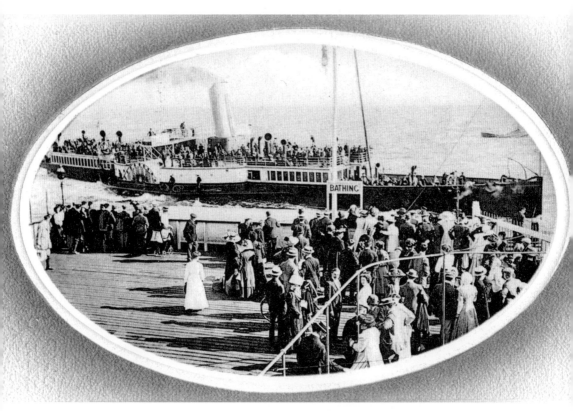

Clacton Pier in its steamer heyday. Clacton never gained the popularity as a destination for pleasure steamer passengers that Southend did. It did, though, provide a valuable calling point, especially with the east coast pleasure steamer route to and from Great Yarmouth.

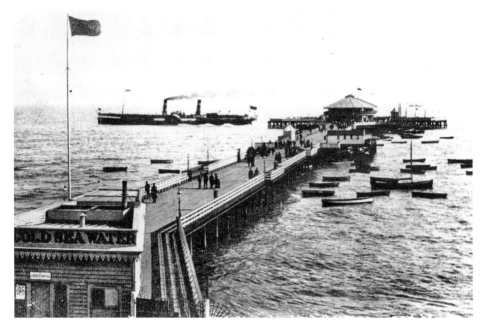

Koh-i-Noor departing from Clacton Pier in 1893. Her facilities showed why paddle steamers were so popular. These included a post office, hairdressers, book stall, fruit stall and a dining saloon that could accommodate 200 people at a time. She also had a fine 300-foot-long promenade deck that was perfect for admiring the scenery during the cruise.

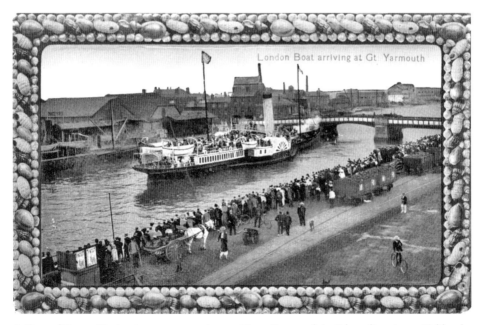

A General Steam Navigation steamer arrives at Great Yarmouth in Edwardian times. Unlike the Thames Estuary, there were few piers north of Walton. A fully developed service therefore never developed from Suffolk and Norfolk resorts.

Clacton's West Beach around 1905. Clacton Pier is one of the most distinctive of all UK pleasure piers due to its great width. This steamer guide advertisement from 1939 clearly shows the open-air swimming pool towards the shore end that could seat 5,000 spectators. The steamer berthing arm was very large and was capable of taking the largest pleasure steamers.

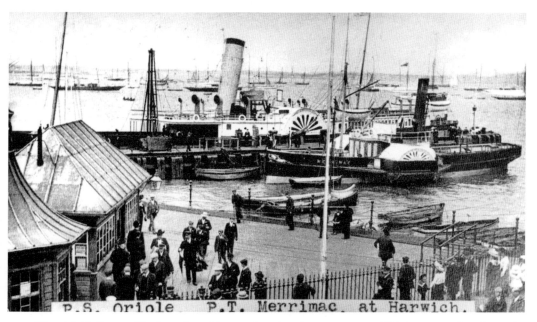

P.S. Oriole P.T. Merrimac at Harwich.

Harwich Halfpenny Pier has a long history of use by pleasure steamers. This inter-war view shows the *Oriole* and *Merrimac* at the pier. After a lengthy period of not being used by pleasure steamers, the distinctive and short Halfpenny Pier was used again by the *Waverley* in the late 1990s.

"WHAT'S ON"—TIME TABLES—ROAD MAPS OF ESSEX AND KENT—WHERE TO STAY—"CLACTON PAGES" 7 to 10

Holiday News

OF
BRITAIN'S
FINEST
COAST
RESORTS
in Essex & Kent

By "Eagle" Steamer to Southend, Margate, Ramsgate, Clacton. From June 8th, DAILY (except Fridays)

GO BY
EAGLE STEAMERS
TO
SOUTHEND
MARGATE
RAMSGATE
AND
CLACTON on SEA.
See the Pageant
of the Thames

VOL. 2. NO. 5. JUNE, 1935. PRICE 2ᵈ.

"The Eastern Fringe of England is ever in the Sun"

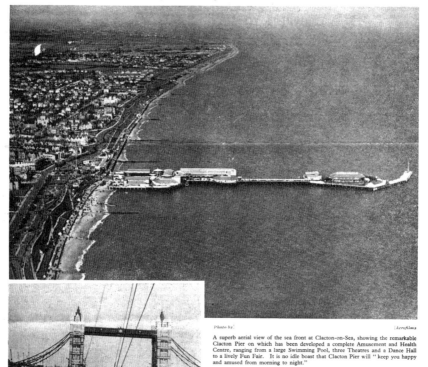

Photo by] [Aerofilms

A superb aerial view of the sea front at Clacton-on-Sea, showing the remarkable Clacton Pier on which has been developed a complete Amusement and Health Centre, ranging from a large Swimming Pool, three Theatres and a Dance Hall to a lively Fun Fair. It is no idle boast that Clacton Pier will "keep you happy and amused from morning to night."

In the photograph will be noticed the new berthing arm at the Pier Head where three large steamers can now berth at one time.

Clacton-on-Sea is going ahead. Modern in style, constantly improving, with delightful beaches, pleasing country around and attractions of every sort, it becomes more popular every year as visitors spread the news of its charms as a holiday resort. The town is in the happy position of being on the bracing East Coast while facing South.

The Pleasure Route to the Coast is on board one of the modern luxurious and fast "Eagle" Steamers which will take you to Southend, Clacton, Ramsgate or Margate, from Tower Pier in the heart of London.

To sit in a comfortable chair on the spacious decks while the ship makes a fast run through the shipping and docks of the Port of London and on through the River Thames where every reach has a link with history, is fascinating.

"EAGLE" STEAMERS' FULL SERVICE STARTS WHIT-SATURDAY

The Sunshine Route to the Holiday Coast

Eagle Steamers were great at promoting their steamers. Their newspaper *Holiday News* was produced in the 1930s and distributed aboard the steamers so that passengers could find things to do at their final destination. It was also great marketing in that it encouraged them to do many

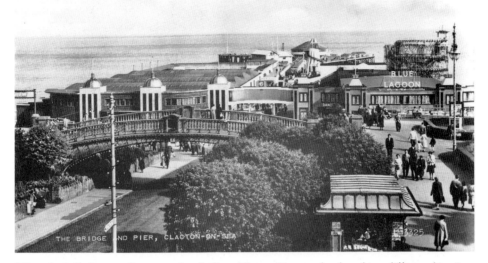

THE BRIDGE AND PIER, CLACTON-ON-SEA

When the Belle Steamer fleet started to decline, Clacton Pier was developed in a different direction. Its 1920s and 1930s heyday saw it develop to become a vast centre of seaside amusement. The pleasure steamers always continued to visit but their role was less central to its future. Between 1922 and 1934 around £200,000 was spent on developing new attractions. These new features included the building of a huge open-air swimming pool that was built uniquely over the sea. Other new buildings included the Blue Lagoon Ballroom and the Crystal Casino. It also had three theatres and a zoo.

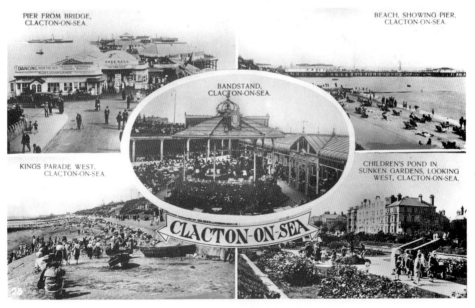

PIER FROM BRIDGE, CLACTON-ON-SEA.

BEACH, SHOWING PIER, CLACTON-ON-SEA.

BANDSTAND, CLACTON-ON-SEA.

KINGS PARADE WEST, CLACTON-ON-SEA.

CHILDREN'S POND IN SUNKEN GARDENS, LOOKING WEST, CLACTON-ON-SEA.

CLACTON-ON-SEA

Clacton was created as a modern seaside resort by Peter Bruff in 1871. Its prime means of access at the time was by paddle steamer. Road access to the resort was always difficult. The pier was opened on 27 July 1871. At the time, it was little more than a jetty.

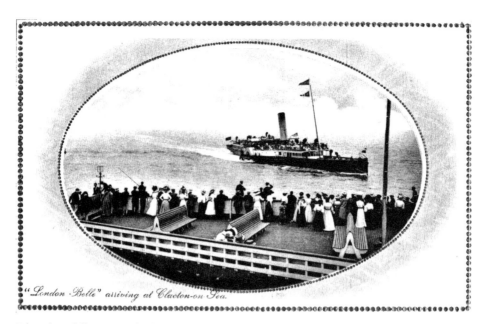

"London Belle" arriving at Clacton-on-Sea.

Edwardian folk, immaculately dressed, on the pier around 1905. The heyday for Clacton Pier was between 1897 and 1915 when the famous Belle Steamer fleet of paddle steamers operated to and from the pier. This splendid and distinctive fleet developed an ambitious timetable of cruises along the east coast as well as to London and the Thames Estuary seaside resorts.

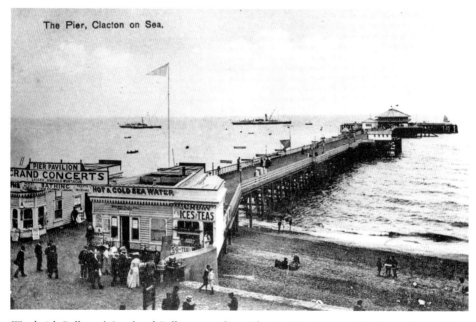

Woolwich Belle and *Southend Belle* approaching Clacton Pier in 1903. Work on the 400-foot-long pier started in 1870. The pier at this time was a very modest affair and was only around twelve feet wide. Clacton Pier was later lengthened to 1,180 feet. Vastly improved steamer berthing facilities were added during the early 1890s.

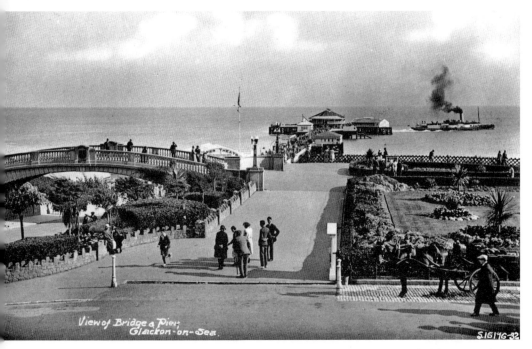

A 1930s view of Clacton Pier and its approach. The building of a major Butlins holiday camp close to Clacton in the late 1930s meant that even more people were visiting the resort. Inevitably, Clacton Pier suffered during the Second World War and several large attractions were lost.

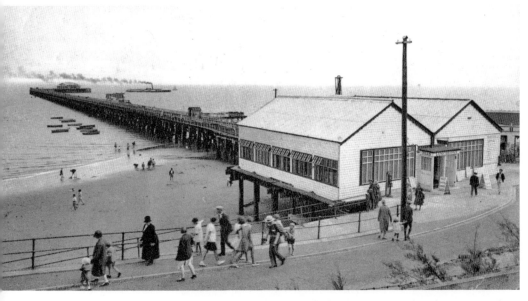

Clacton Belle departing from Walton Pier. This little-heard-of pier was somewhat distinctive with its long, bare structure. The buildings at the shore end can perhaps take the title of most bland and basic seaside pier building in the UK. It is far removed from the flamboyant, dome-topped structures seem at places such as Blackpool and Brighton.

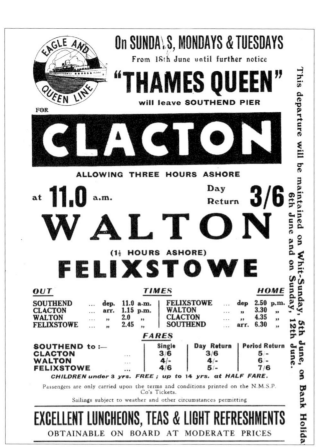

Within the handbill image the following text appears:

On SUNDAYS, MONDAYS & TUESDAYS
From 18th June until further notice
"THAMES QUEEN"
will leave SOUTHEND PIER
FOR
CLACTON
ALLOWING THREE HOURS ASHORE
at **11.0** a.m. Day Return **3/6**
WALTON
(1½ HOURS ASHORE)
FELIXSTOWE

This departure will be maintained on Whit-Sunday, 5th June, on 6th June and on Sunday, 12th June, on Bank Holiday.

OUT		TIMES		HOME	
SOUTHEND	... dep. 11.0 a.m.	FELIXSTOWE	... dep	2.50 p.m.	
CLACTON	... arr. 1.15 p.m.	WALTON	... „	3.30 „	
WALTON	... „ 2.0 „	CLACTON	... „	4.35 „	
FELIXSTOWE	... „ 2.45 „	SOUTHEND	... arr.	6.30 „	

FARES

SOUTHEND to :—		Single	Day Return	Period Return
CLACTON	...	3/6	3/6	5 -
WALTON	...	4/-	4/-	6 -
FELIXSTOWE	...	4/6	5/-	7/6

CHILDREN under 3 yrs. FREE ; up to 14 yrs. at HALF FARE.

Passengers are only carried upon the terms and conditions printed on the N.M.S.P. Co's Tickets.
Sailings subject to weather and other circumstances permitting

EXCELLENT LUNCHEONS, TEAS & LIGHT REFRESHMENTS
OBTAINABLE ON BOARD AT MODERATE PRICES

Handbill advertising cruises by the *Thames Queen* from Southend Pier to Clacton, Walton and Felixstowe during the 1938 season.

Souvenir ash tray from the Eagle Steamers. It has at its centre a small enamelled badge showing the house flag of the company. The General Steam Navigation Company dominated pleasure steamer services on the Thames until they ceased services in 1966.

CLACTON-ON-SEA

Clacton, like other Essex resorts, enjoyed a golden age during the 1920s and 1930s. This was a time when features such as piers and amusement parks had been fully developed and when major fleets of fine pleasure steamers served the piers. Things were initially OK after the Second World War, when families thronged to get back to normal and to enjoy a day at the seaside again. By the mid-1950s, though, things were changing as the car and other attractions made their mark.

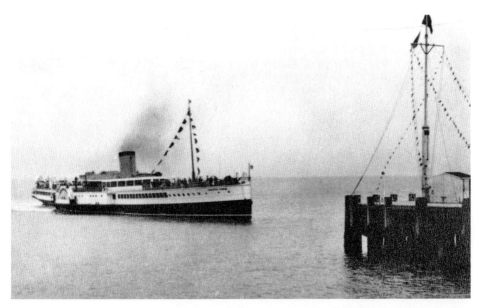

Crested Eagle approaching Clacton Pier on the first day of the season in 1939. That season was to be her last as within months she had been requisitioned for war service. There was a new addition to *Crested Eagle* in 1939 when the modern looking white observation lounge was placed in front of the funnel. This replaced an earlier wooden one. The new saloon can be clearly seen in this image.

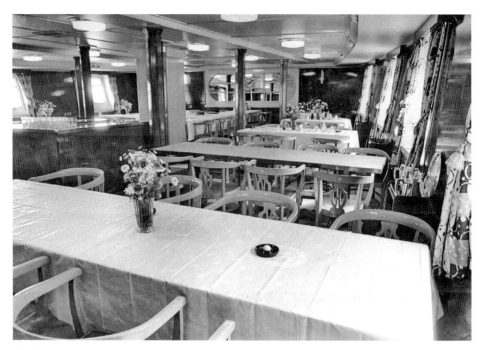

The three GSN motor ships were admired for their smart interiors and high standards of service. They operated in an era when most people enjoyed the formality of sitting down to enjoy a meal in a traditional dining saloon. Old favourites such as fish and chips and roast beef were preferred by most diners.

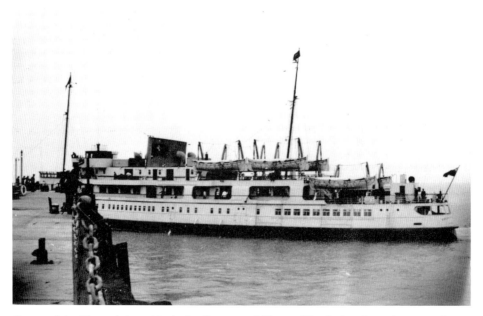

Queen of the Channel alongside the landing arm of Clacton Pier during the early 1960s. *Queen of the Channel* was the smallest of the three post-war motor ships. She could, though, carry up to 1,500 passengers at a speed of 19 knots.

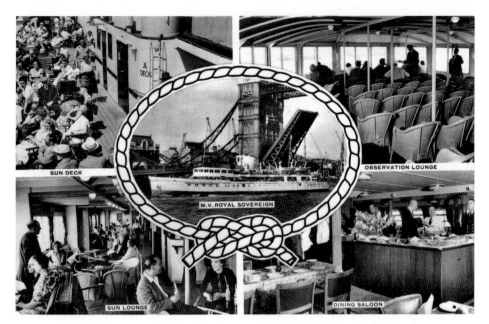

SUN DECK

A DECK

OBSERVATION LOUNGE

M.V. ROYAL SOVEREIGN

SUN LOUNGE

DINING SALOON

The visits by the GSN motor ships to Clacton and later to Great Yarmouth were a much-valued extension to the life of Clacton Pier and its steamers, especially after the *Medway Queen* had made her final call.

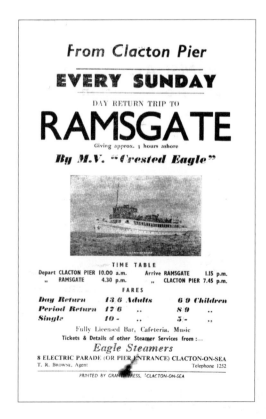

A handbill for cruises by *Crested Eagle* from Clacton to Ramsgate in Kent. This allowed passengers around three hours ashore.

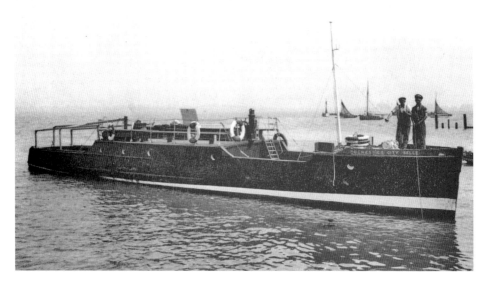

Rochester City Belle was operated by the Queen Line on the Ipswich, Harwich and Felixstowe service. She was an ex motor launch and connected with the pre-war *Queen of the Channel*. She is seen here at Halfpenny Pier at Harwich on 7 August 1937.

Clacton developed as a resort after the coming of the steamers. Other resorts in the area never gained its popularity. Walton-on-the-Naze gained modest popularity during the Belle Steamer era but other resorts such as Frinton and Jaywick were very sedate. Frinton in particular would never have welcomed hordes of rowdy pleasure steamer passengers from London.

In the 1950s and 1960s small chrome items such as tea strainers, matchbox covers, caddy spoons and brooches from the *Royal Daffodil*, *Royal Sovereign* and *Queen of the Channel* were popular souvenirs. By 1966, it was clear that River Thames services by the General Steam Navigation Company were coming to an end. *Royal Sovereign* became a cross-channel steamer for the first time in her career when she cruised between Great Yarmouth and Calais as well as undertaking local cruises. She also took up the Clacton to Calais trips on Thursdays.

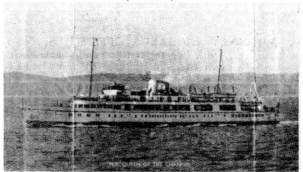
Queen of the Channel regularly visited Clacton. This handbill dates from 1956. It took a little over four hours to reach Calais from the Essex resort. Passengers were then allowed three hours ashore before returning home.

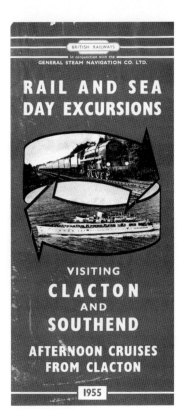

By the 1950s, Eagle Steamers provided close links with
train and bus services. This brochure from 1955 outlines
some of these. Passengers, for example, were able to travel
from London to Clacton by steamer and then return by
train. Popular cross-Channel cruises to Boulogne were also
heavily promoted.

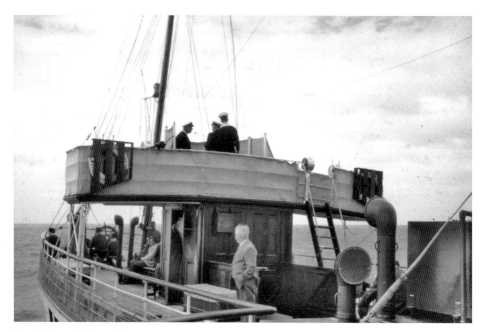

The bridge of the *Medway Queen* on 26 August 1962. A figure forever linked with the *Medway Queen* is that of Captain Leonard Horsham. He became her master in 1947 when she resumed her career after a refit to rectify wartime wear and tear. Leonard stayed with the *Medway Queen* until September 1963, when she was withdrawn from service.

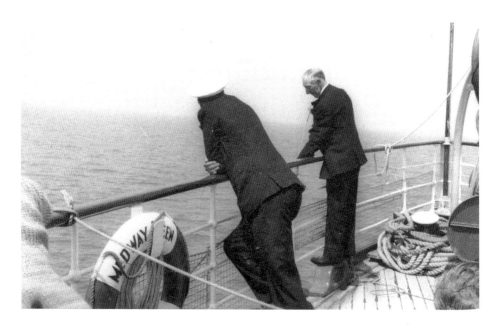

Officers aboard the *Medway Queen* 'casting the lead' on the way into Clacton in 1962. The approach to Clacton by pleasure steamer is quite treacherous, with many large sandbanks. Careful attention had to be paid to ensure that vessels such as the *Medway Queen* navigated these safely.

A cruise by the *Medway Queen* from Clacton to the River Blackwater was popular during the late 1950s. This allowed passengers to see hidden landscapes such as Mersea Island and Jaywick Sands. These cruises were later revived in the 2000s by *Balmoral* and *Waverley*.

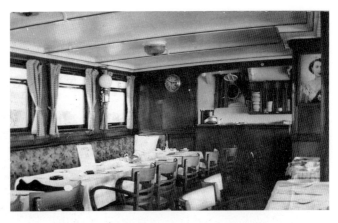

The dining saloon of the *Medway Queen* during a cruise from Clacton in the early 1960s. *Medway Queen*'s greatest moment came at Dunkirk, where she took part in the evacuation. After the Second World War, she was one of only six steamers out of thirteen that had been available in 1939. After reconditioning, she took up the Strood to Southend service again. By 1953 she was operating the Strood to Sheerness, Southend and Herne Bay run with an extra trip between Herne Bay and Southend added in the middle. Sheerness Pier later closed in 1954. *Medway Queen* later ran from Chatham to Southend and then to either Herne Bay or Clacton. On Clacton days, a River Blackwater cruise was added. Her demise was somewhat hastened by the closures of Sheerness Pier and Sun Pier at Chatham. To this was added a cost of around £4,000 to recondition her for service in 1964. There was only one real option for the heroine of Dunkirk.

The Sunken Gardens at Clacton in 1962. Clacton was a smaller sister to Southend due to its distance from the large market of London. It did, though, offer several similarities in the form of traditional amusements and slot arcades and some fine gardens along the cliff top.

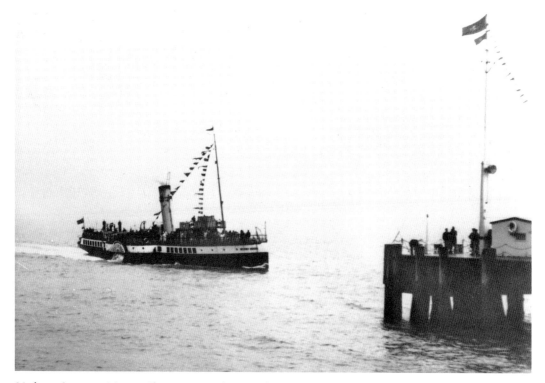

Medway Queen arriving at Clacton Pier on her very last call in 1963.

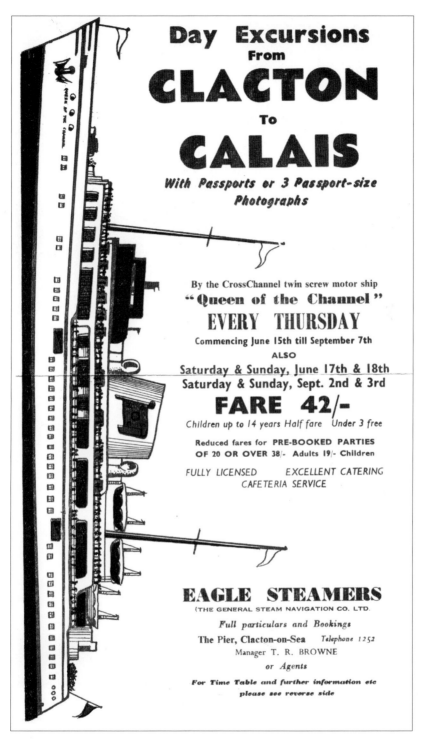

Day Excursions
From
CLACTON
To
CALAIS
With Passports or 3 Passport-size Photographs

By the CrossChannel twin screw motor ship
"Queen of the Channel"
EVERY THURSDAY
Commencing June 15th till September 7th
ALSO
Saturday & Sunday, June 17th & 18th
Saturday & Sunday, Sept. 2nd & 3rd
FARE 42/-
Children up to 14 years Half fare Under 3 free

**Reduced fares for PRE-BOOKED PARTIES
OF 20 OR OVER 38/- Adults 19/- Children**

FULLY LICENSED EXCELLENT CATERING
CAFETERIA SERVICE

EAGLE STEAMERS
(THE GENERAL STEAM NAVIGATION CO. LTD.

Full particulars and Bookings
The Pier, Clacton-on-Sea *Telephone 1252*
Manager T. R. BROWNE
or Agents
*For Time Table and further information etc
please see reverse side*

By the 1960s, the *Queen of the Channel* was offering day cruises from Clacton Pier to Calais at a fare of £2 10 shillings. Passengers were able to exchange up to £50 in foreign currency aboard the *Queen of the Channel*.

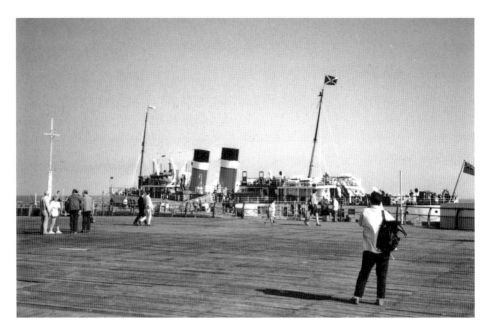

Waverley is embarking her passengers at Clacton Pier for one of her annual evening cruises to London to see Tower Bridge open.

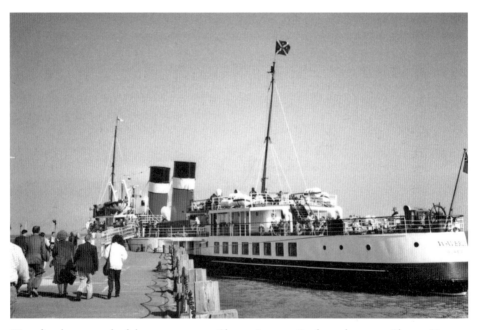

Waverley about to embark her passengers at Clacton in 1997. By the early 1970s, Clacton Pier was declining drastically and many of its attractions, such as the Odeon Cinema and Steel Stella roller coaster, were lost. After storm damage in the late 1970s and 1980s, the pier suffered more damage. Pleasure steamer cruises were restored with the annual visits of the *Waverley* and *Balmoral* from the 1980s. The tradition of taking a pleasure steamer cruise to the coastal seaside resorts of Essex is still alive and flourishing thanks to the annual visits of *Balmoral* and *Waverley*!